IMAGES
of America

FOXBOROUGH

Jack Authelet

IMAGES
of America

FOXBOROUGH

Jack Authelet

ARCADIA

First published 1996
Copyright © Jack Authelet, 1996

ISBN 0-7524-0266-8

Published by Arcadia Publishing,
an imprint of the Chalford Publishing Corporation
One Washington Center, Dover, New Hampshire 03820
Printed in Great Britain

Library of Congress Cataloging-in-Publication Data applied for

Other publications by Jack Authelet:

Glimpses of Early Foxboro (1978)

They Fanned the Flames of Freedom:
Colonial Newspapers in the American Revolution (1990)

Foxborough: a Pictorial History 1778–1978 (1978)
(as Associate Editor)

Contents

Dedication

Dedicated to those hearty pioneers
whose determination turned a dream to reality;
and to those who followed them to this special place,
drawn by that same sense of community
which has made Foxborough
so unique.

Introduction

In the beginning there was the land, uncharted, unyielding. On this high plain, huge springs surged upward from deep within the earth, forming streams that would replenish three watersheds. The Indians would call this place Neponset—Land of the Spreading Waters.

The streams attracted settlers, who laid out huge farms in the wilderness, using the water to sustain cattle, crops, and themselves. Those same waters supported the first tentative departure from dependence on the land, as small grinding shops, grain mills, and saw mills were set up on the streams. The streams would later be dammed up to impound water to power the huge factories and usher in the industrial age.

Captain William Hudson was the first to be attracted to the area. Having purchased William Jefferies' right to lay out a 500-acre farm, Hudson traded it for a grant of 300 acres near Wading River. He built a home in 1669 which he then leased to others.

Hudson sold his farm in 1676 to Thomas Platt, who leased it to Thomas Brintnall of Chelsea in 1681. Thomas Brintnall's son Samuel had a son, Samuel Jr., in 1689, the first white child to be born in the territory that would become Foxborough.

Others soon followed, and their families populated the areas that would become Morseville and Painesville (or Robbins Corner), in recognition of the number of families by those names that lived there. Later these neighborhoods would be North, South, East, and West Foxborough.

By 1718, a stage line had been established, running from Boston to the Bristol, RI, ferry. The stage line ran approximately along the present Mechanic and South Streets which, on early maps, were shown as the road to Bristol.

Jedediah Morse built a home and saw mill in 1734 at Crack Rock Pond at the headwaters of the Neponset River, and was one of the first to harness the stream as a source of power.

Nehemiah Carpenter built a dwelling (on the present Carpenter Street) in 1749 in the middle of what would later become Foxborough, and the first images of a "center" began taking shape.

The number of families increased. They lived here, but each of them belonged to another place, having carved out a homestead in the outer reaches of Wrentham, Stoughton, and Stoughtonham. But they had much in common, a shared dependence of neighbor upon neighbor, and a sense of community evolved.

There had been talk of becoming a community. Their words are not recorded, but they collectively took steps that could lead to being set aside as a town. In 1763, Nehemiah joined

with other early settlers of the center, Samuel Baker and Jeremiah Hartshorn, to provide land for the building of a meetinghouse. This was a prerequisite for being set aside as a separate town. The people took time out from their own labors and erected a meetinghouse. They selected a spot where two dusty roads crossed somewhere near the center of the community they envisioned.

In 1766, when the population of the area had increased to include seventy-three families, they petitioned the legislature for incorporation. They led a hard life, working from early in the morning until late in the night, and sought relief from the 4 to 8-mile journey they had to make to attend meetings in their respective towns on the Sabbath.

Their petition was denied, but they were not deterred. They resubmitted it in 1768 and again in 1771, with each petition raising hopes they would eventually succeed, and each denial met with a vow to try again.

Meanwhile, there were practical considerations, like educating the children. Again, they were drawn together by a sense of community, and in 1770 erected a school building on Chestnut Street and made arrangements to provide instruction. Two years later, another school would be erected at Robbins Corner (East Foxborough).

Determined people appealed to the legislature again in 1773, citing the great distance they had to travel to worship in their respective towns. Again, they were denied.

By now, more pressing matters occupied the legislative leaders, for there was considerable unrest in the Colonies. Captain Josiah Pratt of East Street was a member of the Committee on Correspondence. He was there in Doty's Tavern when the Suffolk Resolves were signed and carried by Paul Revere to the Continental Congress meeting in Philadelphia. The document became the blueprint for the Declaration of Independence. Ezra Carpenter would eventually march to Concord and Lexington, and cross the Delaware River with General Washington on Christmas night in '76. Many others would serve with distinction and their service would later be credited to Foxborough. The first to be inducted "from Foxborough" following incorporation was Zadoc Howe. There is a monument to his memory behind Memorial Hall.

With the successful fight for independence came a shift in sentiment in the legislature, and the 1773 petition for incorporation, which had been denied, was reconsidered—this time favorably! The date was June 10, 1778. And for whom would the new community be named? News had just reached the Colonies of yet another impassioned presentation before Parliament by Charles James Fox, who was unrelenting in his support for those desiring independence. It was decided that he would be a fitting choice, and that the new community would be named Foxborough.

This was a time of great rejoicing, except for seventeen families in East Foxborough. By choice, they retained ties with Stoughton, but would later join the new community.

At the first town meeting on June 29, 1778, the first town officials were elected and they put into place a form of government which still functions today.

By 1789, they had established school districts, with each of the outlying areas as well as the center being served by an elementary school.

It was in 1798 that an obscure event of little note took place, far from the borders of the new community, that would usher in what may be considered the Gilded Age of Foxborough. It bought unparalleled prosperity to both the town and its residents, and signaled the start of a series of civic improvements that would be the envy of most communities of that time.

It was the start of the straw hat era, and it all began with a young girl of twelve who stood admiring a straw bonnet displayed in a store window in Providence, RI.

Her name was Betsy Metcalfe. One source identifies her as a resident of Providence. Another said she worked for a milliner in Wrentham. But all agree that she admired a bonnet she could not afford. So when she arrived back home, she gathered rye from her father's field, split the straw with her thumbnail, and fashioned the first straw bonnet made in America. (It is presently in the possession of the Rhode Island School of Design as part of their extensive collection of straw hats and hat boxes, and was on loan to Foxborough for one month during

our bicentennial celebration in 1978.)

Betsy's friends from Foxborough were fascinated by her new bonnet, so she taught them how to split and braid straw. Among them were Eunice Everett, who made the first "Foxborough" straw hat, Sally Mann, Annie Leonard, Patty Carpenter, and her cousin Polly.

The commercial value of the hats was obvious, and quickly there were small manufacturing shops everywhere.

Mrs. Cornelius Metcalf of Granite Street opened a manufacturing operation in what is now the home of Attorneys Garrett and Frances Spillane. Mrs. Metcalf adopted several children and took in apprentices to carry on her business.

Elias Nason sold straw goods in his store. Nehemiah Carpenter joined Nason in the business. Daniels Carpenter and John Corey each paid cash for labor and manufactured goods on a larger scale. (Corey was lost when the steamer *Lexington* burned on Long Island Sound in 1840.)

Demand for the products led to more stores and more manufacturing. Ezra Carpenter Jr. began taking straw hats made in Foxborough to market in Boston. By this time, straw hats were clearly making their mark on the village, and a large "cottage industry" evolved. Each morning wagons carrying straw would leave from the manufacturing places, taking straw to women who braided and fashioned the hats at home.

These were not the only winds of change. Stratton Manufacturing was started in 1812 on Water Street by Squire Elias Nason. He manufactured thread and yarn in large quantities.

In 1822, the Meeting House was removed, and the Congregational Society and Baptist Society, which had been meeting there, then built the first formal churches. The Congregational church, made of brick, was erected on what is now the Common at the head of Rockhill Street. The Baptist congregation erected their church on Elm Street, which was then the main road to Mansfield, since the upper reaches of Central Street had not yet been built.

More families were drawn to the center. A business district evolved, and the imprint of the center was finalized with the building of the Universalist church facing the Common in 1843.

The straw business continued to expand. The Great Bonnet Shop was built on Wall Street in 1844. Straw manufacturing attracted numerous visitors, and the Cocasset House (on the present site of the Foxboro National Bank) was erected in 1846 to accommodate them.

The original Baptist church, which had been moved to the present site of Town Hall, was abandoned in favor of a new edifice with a tall spire which faced the Common. It was erected in 1850. That same year, the Foxboro Fire Company was formed, and purchased its first apparatus—an 1851 Hunneman engine—the following year.

The straw hat industry had spread throughout the community. In 1853, there was a move to consolidate, and the Union Straw Works was built on Wall Street. The huge complex of wooden buildings, three stories tall, stretched 1,000 feet from the road.

The new level of prosperity in the village is best demonstrated by the events of 1857, a year which defined early Foxborough. With a population nearing 3,000, and hundreds more living in boarding houses provided by the manufacturers, the town beautified the area in the center and the Common was laid out as we know it today. The fence was cast in the Cary Foundry on Mill Street. The Town House, a magnificent structure built to house town offices, and later a public high school was built on the present site of Town Hall. Liberty Street was laid out to access the new facility. The fire station was located immediately behind the Town House.

There was a financial panic that year, and most businesses suspended operations. The Union Straw Works was no exception, but no hourly employees lost any wages, and management offered to work the following twelve months at half pay to facilitate recovery.

At the outbreak of the Civil War, Foxborough had the oldest militia unit in the Commonwealth. Company F soldiers were the first to march on southern soil with the stars and strips. But it would be a time of testing for the young community, which would be called to bury twenty-one of its sons as a result of the conflict. Deciding on a "suitable monument," the community erected Memorial Hall as a tribute "to all those whose lives were touched by the war."

The business district was now populated by tinsmiths, grocers, cobblers, apothecaries, barber shops (ladies hair was cut at home), and launderers.

Passenger trains passed through East Foxborough on their trips between Boston and Providence and a freight line opened the center to the broader world in 1870.

In the centennial year of 1878, the third attempt by the Catholics to build was successful, the first two being thwarted by fire and lightening.

The community was truly coming of age. There were demonstrations in Town Hall of telephones and electricity, and natural gas would be available in the center, produced by the Union Straw Works. In 1879, the Foxboro Water Supply District was formed, and within a few years, indoor plumbing became reality for many families.

But by the time the cornerstone of the Episcopal church was laid in 1893, there were clear signs of change in the community.

The straw hat industry was in decline. Hopes for continued prosperity rested with the Van Choate Electric Co., which was erecting a huge complex of buildings on Neponset Avenue. The company held patents for manufacturing electrical devices.

Somewhat apprehensive, the community rushed headlong into the new century, but 1900 would be a disastrous year, a time of challenge for the village.

The Van Choate Electric Co. went into receivership. There would be no jobs or return on investment that the hundreds who had purchased stock in the company had made.

On May 28, at 7:20 pm, the fire alarm rang. The Union Straw Works—the world's largest straw hat factory— was engulfed in flames, and totally destroyed in about ninety minutes. The community was stunned, but the worst was yet to come.

On June 4, at 4:40 am, even while a fire watch remained on duty at the hat factory, the Town House became engulfed in flames. Without warning, the tower collapsed, and the huge bell went crashing down. Three firefighters lost their lives that night, and a community mourned. All the town offices were gone, as was the high school. But concern rested with the widows and children of the firefighters, and volunteer efforts turned to raising funds for their care.

The Van Choate buildings stood empty when, in 1908, Bennett and Edgar Bristol broke away from the family instrument business in Connecticut. They formed the Industrial Instrument Co. and then acquired the Standard Gauge Co. On July 7, they paid $65,000 cash for the brick complex on Neponset Avenue and the economic recovery of the community was underway. In 1914, the Bristols reorganized and changed the name of their business to the Foxboro Company.

The center continued to expand. Trolley cars carried people by the hundreds to the broadly-expanding world between Mansfield and Norwood.

When residents gathered to celebrate the sesquicentennial in 1928, the community had a proud past and a bright future. Change would remain a constant, and the automobile would bring about nearly as much of that change as did Betsy Metcalfe's bonnet. But the future was calling, and the community was ready.

The photographs on the following pages offer a glimpse of those who made a town a community. The photographs are from the collection of the Foxborough Historical Commission; this publication will share many of them with the public for the first time.

In limiting the book to a single collection of photographs, we have had to accept three limitations in what we can share: was it ever photographed, was the print preserved, and did it come into the public domain?

The photographs are arranged, as much as possible, to form a social commentary on life in Foxborough from the mid-nineteenth century through the town's sesquicentennial in 1928.

Jack Authelet
January 1996

One
How They Lived

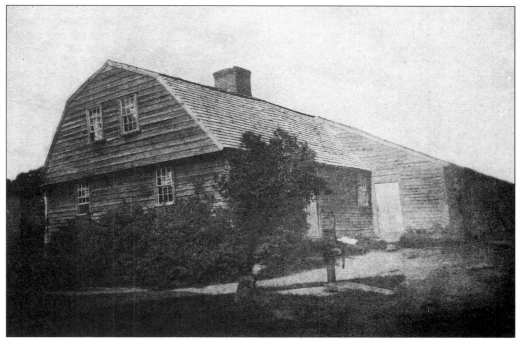

This house, built by Nehemiah Carpenter in 1750, was the first residence in the center of the area that would later become Foxborough. Mr. Carpenter, active in the movement to create a new town, donated land for the burial ground in the center and was one of three men to donate land for the Common where the Meeting House was built. He occupied Pew 35. He was one of twenty-nine original incorporators of the first church, serving as deacon until his death in 1799. Three of his sons—Ezra, Nehemiah Jr., and John—served in the Revolutionary War. Nehemiah served as town clerk in 1784 and 1785 and selectman from 1780 to 1787. He was also a constable for a number of years. This building was dismantled in 1880 by J.W. Carpenter, who used the frame to build a lumber shed.

The Wood-Sumner House, located at 44 Mechanic Street. In 1782, Joseph Day sold 40 acres of land to Joseph Field, a blacksmith. He in turn sold the land to Dr. Joshua Wood in 1789. Dr. Wood would occupy Pew 2 in the Meeting House on the Common. Discussions around the woodpile of a later owner, John Sumner, led to the formation of the Universalist Society in 1837.

Seth Boyden built the Boyden Homestead at 135 Oak Street, c. 1770. The husband of Susannah Atherton, Boyden was a proprietor of the Undivided Lands. During the Revolution he was captured by the British and held until the close of hostilities. He served as selectman, justice of the peace, and representative to the General Court. His sons were a creative and industrious bunch: Seth was an inventor; Uriah redesigned the water wheels which saved the textile industry in Lowell (Boyden Library bears his name); and Alexander started the malleable iron works in Easton, which is still in operation. Owned by Dr. and Mrs. Roy Greep, the property is believed to have been a stop on the Underground Railroad for runaway slaves.

The Dorchester School Farm at 343 South Street is currently being refurbished by Carl and Dale Anderson. In 1700, the Committee of Dorchester laid out a farm near Wading River to be leased, with the proceeds being used to pay for the schools. One of the lessees, for two terms totalling 298 years, was Robert Calef of Roxbury. Upon Calef's death, his son-in-law, Solomon Hewes of Portsmouth, NH, took over the lease and moved his family to Foxborough. Records indicate there was an earlier building on the site.

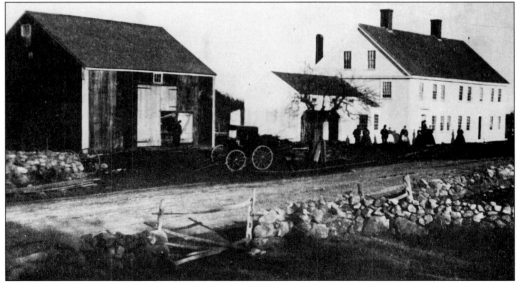

The Comey House was located on Cocasset Street, opposite Elm. John Comey was one of the original petitioners in 1773 who asked that this area be set aside as a town. He occupied Pew 5 in the Meeting House, and was elected constable at the first town meeting, held on June 29, 1778.

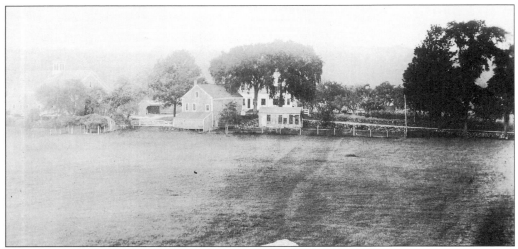

The Daniels Farm on West Street is shown here, as viewed from across the field. Francis Daniels (Francois Guideau) was a native of Normandy, France, and was an officer in the French Army before he was captured by a Colonial privateer and brought to Boston in chains. When released from prison, he worked for the Hewes family in Wrentham to pay off his passage money. In 1759, he purchased 53 acres in Wrentham which would be the start of Normandy Farms. The area became Foxborough in 1778.

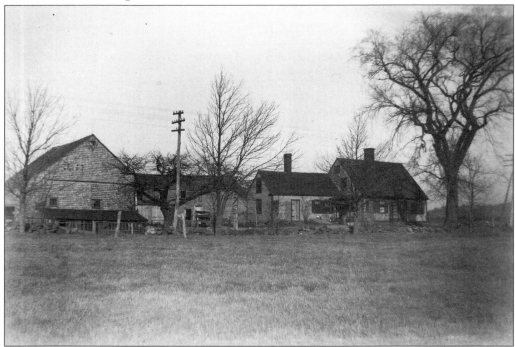

This is a later view of the Daniels homestead. The family, which occupied Pew 17 in the Meeting House, has been working the land continually since 1759. Family members in the original homestead continue to raise Christmas trees; others run Normandy Farms Campground, rated one of the finest facilities of its type in the nation. West Street was the first street accepted as a town road following incorporation in 1778.

The Stratton Homestead, later owned by Frank Carpenter, was located off Stratton Lane. The land is now part of the Foxborough Country Club. George Stratton was one of the founders of the foundry on Mill Street. He was also a principal in the Stratton Manufacturing Co. on Water Street, producing thread and yarn. He occupied Pew 3 in the Meeting House.

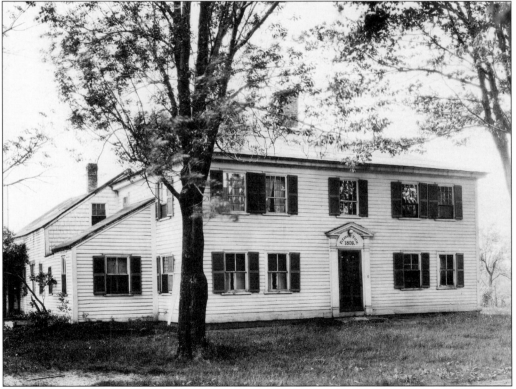

Pleasant View, the Payson family homestead on Cross Street, has been dated to 1806. Other family members owned much of the original Foxboro State Hospital land. Swift Payson was a 2nd Lieutenant in the Wrentham Co., which marched to Concord and Lexington on April 19, 1775. He was the first town clerk once Foxborough became a town.

The home of Deacon Samuel Baker was built 1767–69 in the present-day center of town (on the site of the present Aubuchon Hardware Store). Active in the incorporation of the town, Deacon Baker was one of the three donors of land for the Common. Three generations occupied the house—Deacon Baker, Eleazer Belcher Jr., and Squire Warren Bird. The home was enlarged using lumber from the first schoolhouse on Chestnut Street.

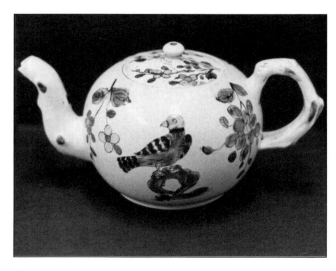

When the British imposed a tax on tea, Deacon Baker vowed no tea would be drunk in his house, but while the men were working in the fields, the women used this tea pot to brew their prohibited pot of tea. Members of the Turner family, descended from Deacon Baker, donated the tea pot to the Foxborough Historical Commission. During the 1814 typhoid epidemic, three members of the household— Mary Bird, her grandfather, Eleazer Belcher Jr., and her great-grandfather, Deacon Baker—all died within a three-day period.

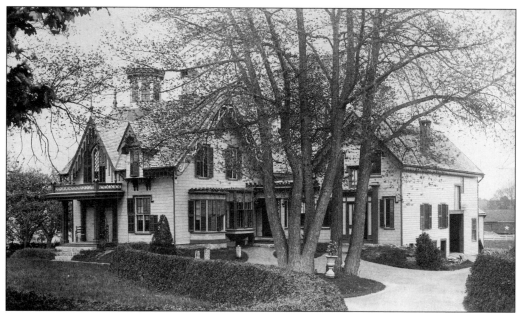

Baker descendent Catherine Bird married Willard P. Turner, and they built "the gingerbread house" at 13 Baker Street in 1835. The first house built on the street, it has recently been restored by Jeff and Lisa Davis. Willard W. Turner built the house next door at 9 Baker Street in 1887, now being restored by Tom and Maureen Kraus. The Turners had a cranberry bog on the Foxborough/Sharon town line.

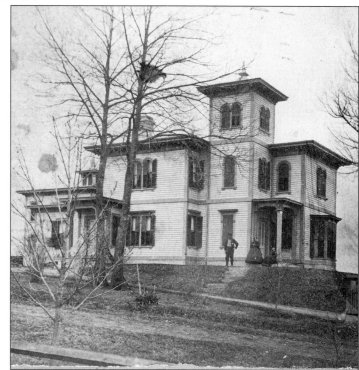

Baker descendent Angelina Bird married Ezra Pickens, a master mariner, and they built this Italian Villa-style home in 1847. Captain Pickens' voyages in search of sperm whales lasted three to four years at a time. After giving up the sea, he was a founder of the Foxboro Jewelry Co., operated a steam laundry, worked at the Union Straw Works, and was a principal in the Cocasset Improvement Co. and Bay State Improvement Co., which induced many businesses to locate in Foxborough. His home, located at 12 Baker Street, is owned by Frank and Clare Barros.

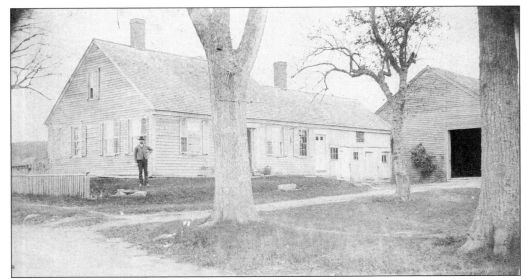

The Silas Buck House on Central Street was built by Asa Paine, *c.* 1790. Members of the family were numerous in the Foxvale section (Central, Spring, and County Streets), and the first school even bore the Paine name. This home, at 298 Central Street, originally faced the back of the property; when Central Street was built, the building was turned 90 degrees.

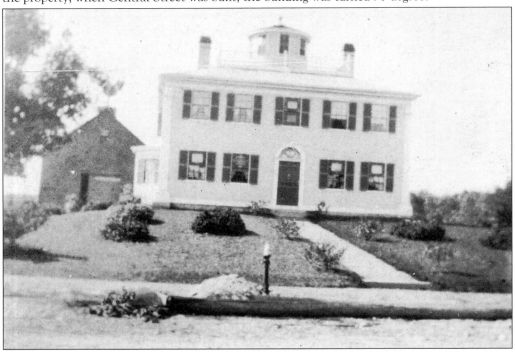

The home of Judge Ebenezer Warren on Central Street was built in 1806 and burned on December 26, 1905. Judge Warren served the county court, and was brother to General Joseph Warren, who died at Bunker Hill. Judge Warren was a delegate to the Constitutional Convention in 1788 that adopted the Federal Constitution. He also served as a member of the General Court in 1783.

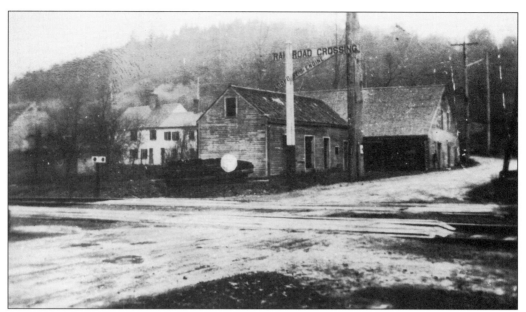

The Leonard Morse hoe factory at the railroad crossing on North Street produced $15,000 worth of goods in 1837. The area was settled by members of the Morse family as early as 1730—hence the name Morseville in the town's early history. David Morse held Pew 38 in the Meeting House and most of the old homes in the vicinity of the railroad were built by Morses.

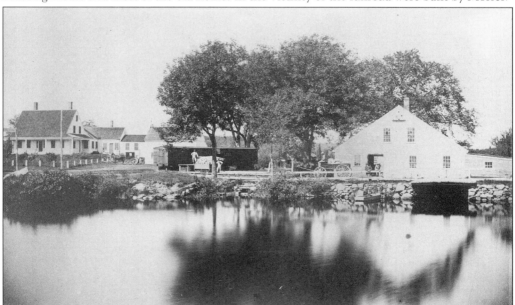

Jedidiah Morse built a dam to harness the Neponset River in 1734, and created a forge on the site (North Street). Other family members would later operate a saw mill, triphammer, hoe factory, and grist mill. The house at the left was built by Leonard Morse in the early 1800s and once served as the North Foxborough Post Office. A later occupant, Henry Turner, hand-carved all the woodwork in two rooms. The Morses were early members of the Universalist Church.

The second home of Nehemiah Carpenter was located in the center of town. It stood at the corner of Central and South Streets where Allied Auto, O'Reilly's, and the Craft Co-op now stand. One of the most influential families in Foxborough, the Carpenter presence would be felt for more than two centuries. The last family member serving the community was Lawrence Carpenter, named postmaster following World War II.

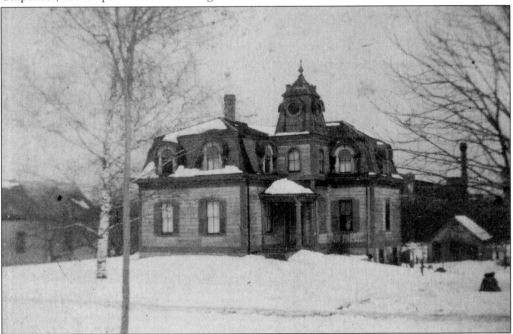

Built by Learge Samuel Wheeler in 1872 at 29 Baker Street, this classic building with its mansard roof was home for many years to Mildred Wheeler, a postal worker. It has been restored by the present owners, Mark and Beth Ferencik. A historically-accurate addition is under construction.

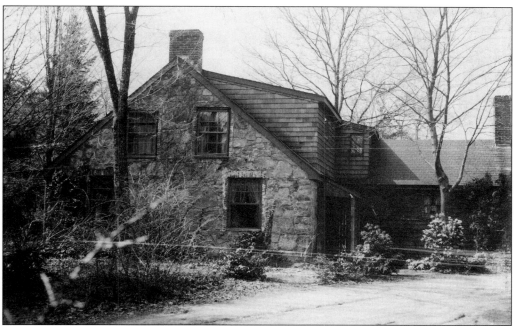

The old stone house on Chestnut Street was demolished in 1972. It had been built by Willard Comey, who owned a thriving charcoal business. Henry Clay Wheeler, who occupied the building for about thirty-five years, deeded it to the Town of Foxboro in 1916 "in consideration of the love and good will" he had experienced here. The town later sold the property. He also donated portraits, painted in reverse on glass, of Benjamin Franklin, Napoleon, George and Martha Washington, and Abraham Lincoln, some of which are hanging in Town Hall.

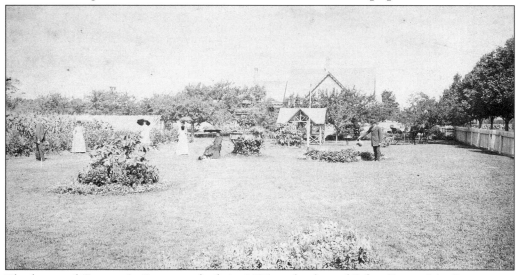

The home of George A. Scott was built in 1885 at the foot of Baker Street. Mr. Scott was a master builder, having erected more than one hundred homes in Foxborough near the turn of the century. Scott built the Young Block (p. 70), the town's first luxury apartments. His home was purchased by the Commonwealth of Massachusetts as part of the state hospital complex. Now stripped of its ornamentation, it is boarded up and faces an uncertain future.

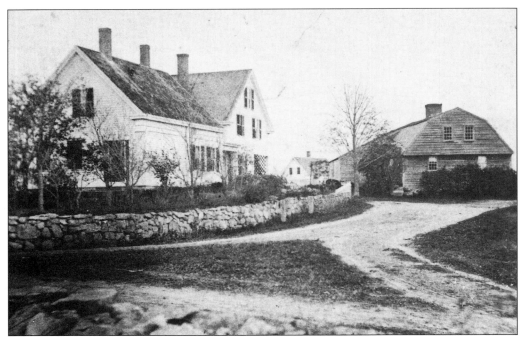

The Inman home, at the corner of South and Carpenter Streets, was the residence of the late Nellie Inman, a beloved teacher at the Junior and Senior High School across the street. This photograph helps pinpoint the location of the Nehemiah Carpenter home, seen at the right, the first to be built in the center of town (p. 11).

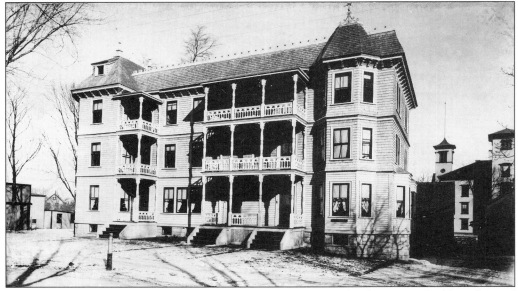

The Young Block was built in the heyday of the straw hat era. The three-story building, located on the present site of the Foxborough Savings Bank, was designed by E.P. Carpenter, a principal in the Union Straw Works, located adjacent to the building. Living accommodations for workers was a major concern for early industry, and many firms built boarding houses for the workers. The Young Block was gutted by fire in 1971.

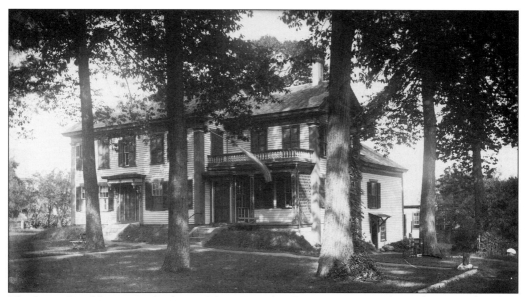

The Lewis Pond home was built in 1854 at 21 Baker Street. Lewis Pond was the son of General Lucas Pond and was a shoemaker by trade, which he carried on for a number of years at the box factory on Market Street owned by his brother Virgil (p. 36). When the Universalist church was hit by fire in the early 1860s, Lewis Pond rescued the pulpit Bible, running his fingers along the edge to put out the flames.

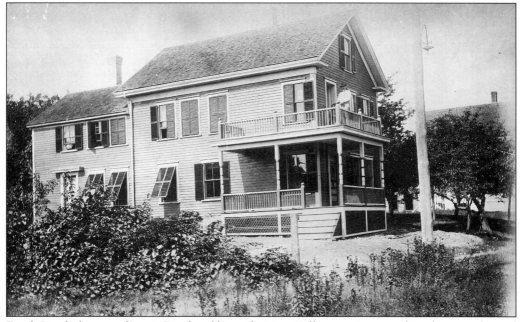

Frank Pond, the son of Lewis Pond and his wife, Mary Fuller, was interested in photography and stereoscopic pictures. Lewis built him this building at the rear of the property (now 33 Railroad Avenue) for use as a studio. It was used as a photographic studio for many years, except for the period from 1887 to 1889 when it was used for shoe manufacturing by Cushman and Evans, George Burgess, and John Gardner. It has since been converted into a residence (p. 63).

Allen Doolittle built this stately home on Bird Street in the early 1850s. Allen had worked at the Cary Foundry and later at the Union Straw Works. In 1915, his daughter Sarah donated the homestead of her late parents to the Universalist Church to provide proper care for elderly persons. The Doolittle Home was considerably expanded in 1932 to its present configuration in the old section. The Sailer infirmary wing on the Bird Street elevation was added in 1962.

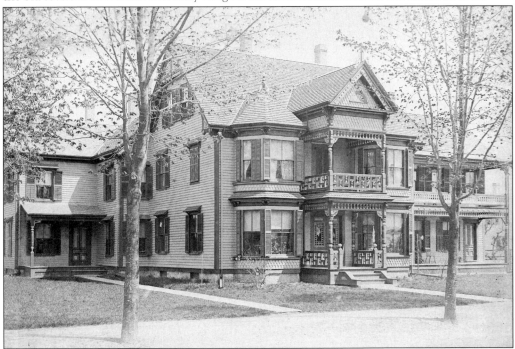

This multi-family dwelling is located at 22 Cocasset Street. The building is notable for its luxurious appointments of bay windows, two porches at each level, and elaborate woodwork. The center porch portion of the structure has been removed.

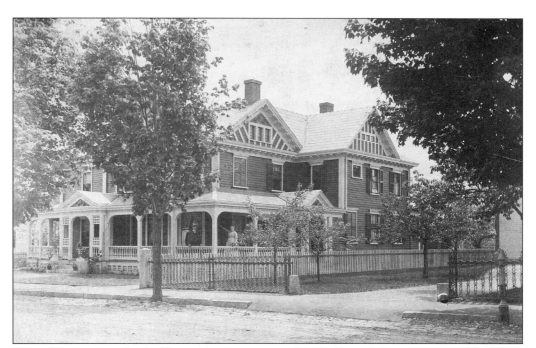

Every day we drive by buildings like this one, at 91–93 Central Street, unmindful of how significant they were for their times. Erected in the late 1800s, it speaks to the prosperity of the period and the talent of its builders.

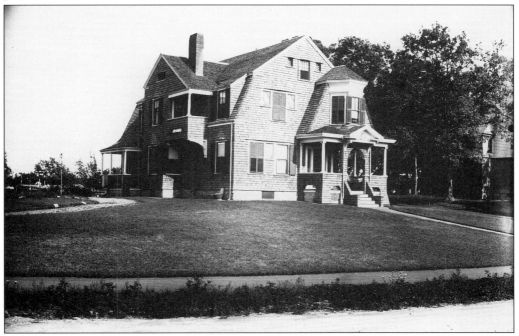

A marvel of turn-of-the-century architecture, this Maple Avenue home was erected c. 1900 for a Mrs. Pratt. Shutters were functional in those days, and the configuration of the house indicates it accommodated more than one family.

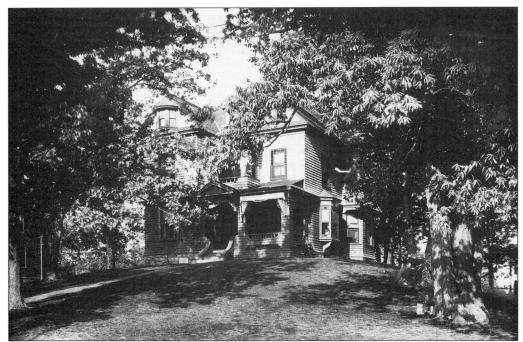

This exceptional home at 9 Maple Place has both a first and second-story porch and a bay window on the third floor. It was built in 1877 for A.T. Starkey, treasurer of the Union Straw Works, who was active in state Republican Party activities. Now the home of Mr. and Mrs. James Graham, it is an English-style house with a hipped roof relieved by gables.

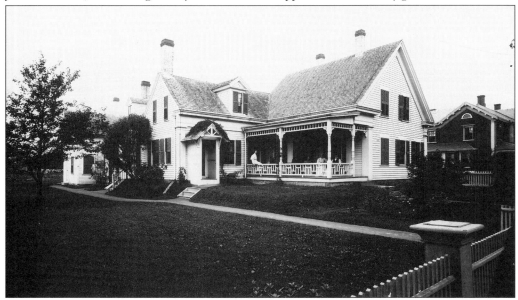

Considering the number of chimneys, this house at 95 Central Street was probably built before the advent of the water supply district and relied on fireplaces for heat. There is no evidence of facilities for horses and wagons, another indication of how the family lived. The house has been extensively remodeled for apartments.

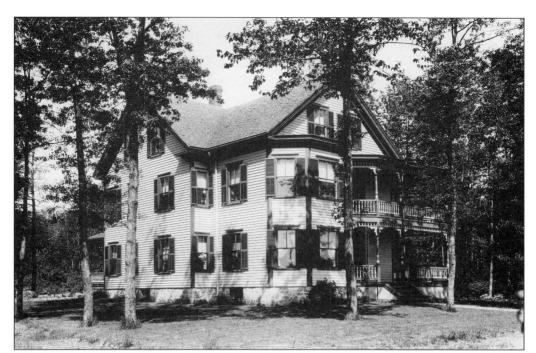

The home of Attorney George Ellis was located on Pleasant Street. In a move unprecedented at the time, Mr. Ellis was joined in his law practice by his daughter, Attorney Grace Ellis (Donovan), who carried on an active law practice for many years. A specialist in land transactions, she provided valuable assistance to the Foxborough Historical Commission and was an officer in the Foxborough Historical Society.

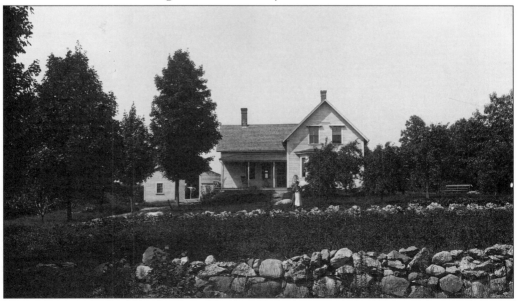

The Otis Potter House on North Street was typical of late-1800s construction. Much of the land in front was devoted to vegetable gardens and the family also maintained numerous fruit trees.

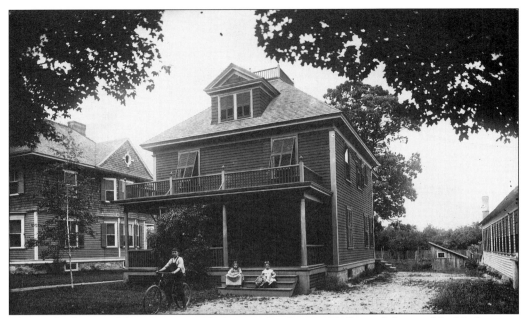

This is the home of former Town Clerk Louis Hodges at 92 Central Street. Mr. Hodges was town clerk in 1900 when the Town House was destroyed by fire. He entered the burning building to retrieve town records, escaping just moments before the bell fell, killing three firefighters.

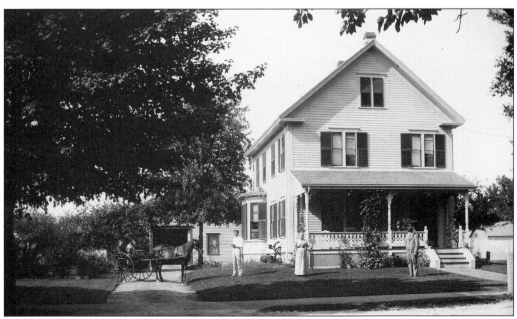

The home of Deacon George Hunt was located on Central Street. Typically, family members gathered for photographs. Most homes of that era included barns to provide for horses and wagons.

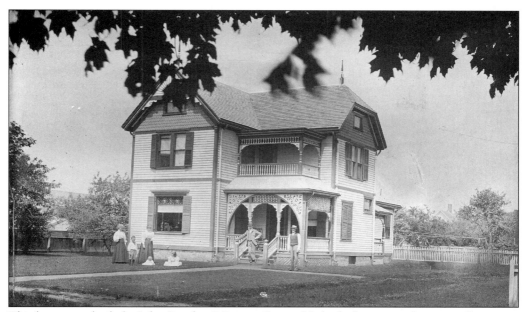

This home was built for John Pond at 3 Bassett Street. He had a large greenhouse on Carpenter Street, a business that he began with W.D. Plimpton in 1870. Pond earned a first prize in 1890 for his Golden Triumph carnation. The home remains unchanged from the time it was built and is in mint condition.

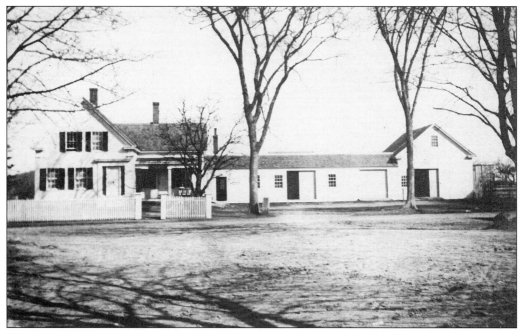

The Seth Wilbur Home on Spring Street. The barn burned on March 26, 1904. There had been a family graveyard in the area but the graves have been removed to Rock Hill Cemetery.

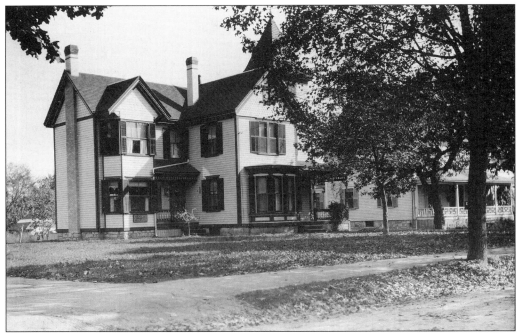

For many years this building, located at 22 Main Street, was the residence and office of Dr. Francis C. Buckley.

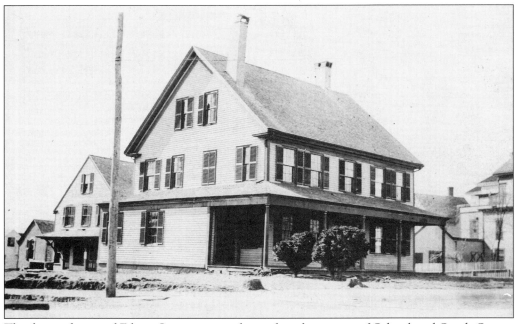

The former home of Edson Carpenter was located at the corner of School and South Streets overlooking the Common. To make way for the first Foxborough Savings Bank building (now Foxboro Photo and Imaging), the home was moved around the corner onto South Street, where it stands today.

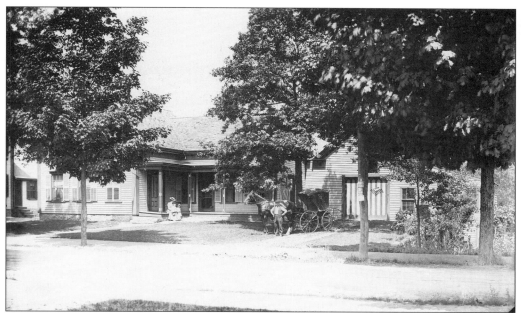

Orlando McKenzie, a blacksmith (p. 62), owned this home, located at 98 Central Street. He came to Foxborough from Norfolk in 1905, and served in the Massachusetts Legislature from that district as well as from the Foxborough district. He served on the board of selectmen, was treasurer of the Foxboro Brass Band, and was the junior warden of St. Alban's Lodge at the time of his death.

Factories were part of the neighborhood prior to the turn of the century, and the majority of jobs were found within walking distance of the center of town. Here, Granite Street intersects with Market, which led to the Pond Stream Mill in the background

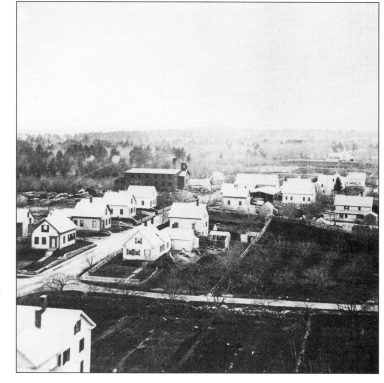

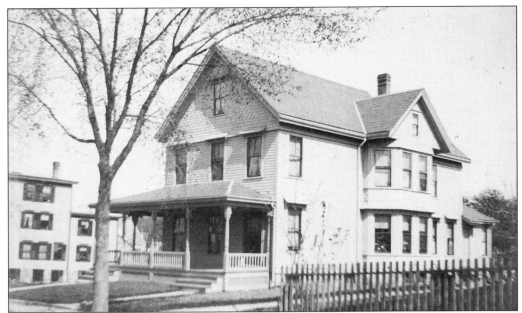

The home of Attorney Robert W. Carpenter on Bird Street was built just before the turn of the century. The front has been rebuilt for the Foxborough General Store. Attorney Carpenter wrote the history for the Foxborough 1890 Directory, wrote for the *Boston Globe* under the name "Winthrop," and is credited with preserving much of Foxborough's history.

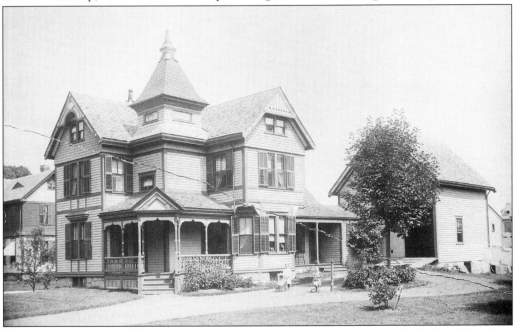

The home of Marge and Jack Authelet is located at 7 Baker Street. Built for Edward R. Williams, a foreman in the shipping room of the A.F. Bemis Hat Co., this *c.* 1890 home was erected immediately prior to the establishing of a central water district. Indoor plumbing was added later.

Two
How They Worked

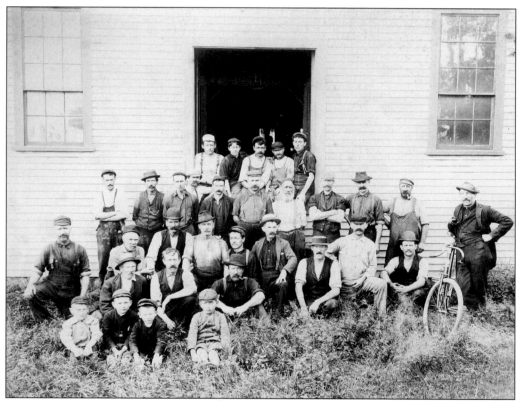

The Foxborough Foundry on Mill Street, started in 1781 by George Stratton, Uriah Atherton, Joseph Hewes, and John Knapp, was the first major industry in the community. It was hard work extracting the iron, working with molten metal, and pouring huge castings for pots, kettles, and stoves. Sand had to be hauled for the molds, and moving the finished product was a challenge, due to its weight. The work attracted many men to the community, and the company prospered.

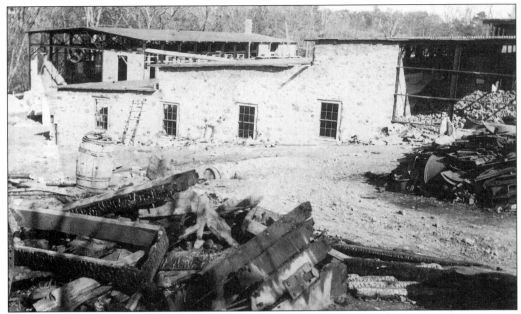

The Foxborough Foundry buildings, where the first casting was made in 1784. In 1812 the business was sold to General Shepard Leach of Easton, and in 1834 Otis Cary and Martin Torrey became the owners. By 1837, twenty men were employed, producing 300 tons of castings. Otis Cary became the sole owner in 1839, and he prospered by discovering how to extract additional ore from the slag heaps that had formerly been considered waste.

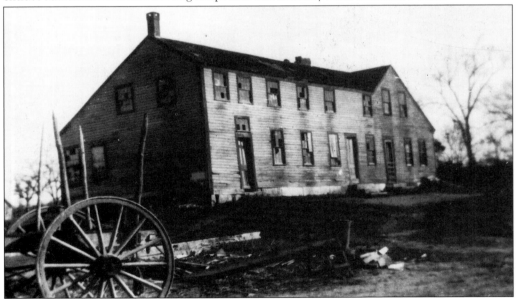

This boarding house was built for workers at the Foxborough Foundry. It was located at the corner of South and Mill Streets and was removed between 1922 and 1926. The foundry buildings burned in 1867 and were rebuilt. In 1878 the business became the Foxborough Foundry and Machine Co. Castings for the Common fence, gates for Rock Hill Cemetery, and casings for the Rotary Shuttle Sewing Machine Co. were made at the foundry.

This home was built by Otis Cary, foundry owner, at 242 South Street. Mr. Cary donated the land for the Cary School (the building to the left of the Taylor School) and was the first president of the Foxborough Savings Bank. His son Otis became a missionary to Japan and the fourth generation of his family still serves there. Dr. Frank Boyden, a Cary descendant, was headmaster of Deerfield Academy for more than fifty years. The house was later occupied by the Dorsey, Belko, and Calder families.

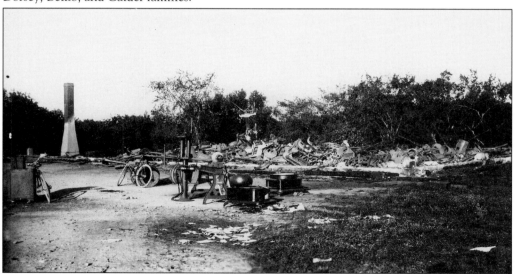

The final chapter of many local businesses was written in ashes as huge buildings, most of wood-frame construction, were destroyed by fire. The Foxborough Foundry and Machine Co. was no exception; the destruction on Tuesday night, September 14, 1897, was total, as virtually nothing survived other than finished iron products and brick work. The buildings were rebuilt, but the business never recovered and it failed shortly thereafter.

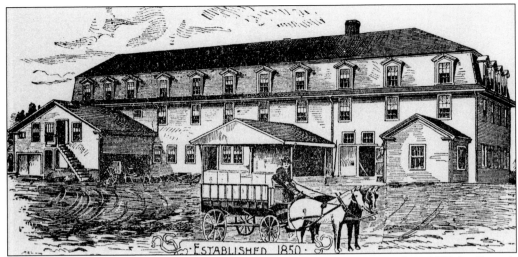

The Foxborough Steam Mill Company on Market Street was organized in 1850 by Daniels Carpenter, J.F. Pond, and Virgil S. Pond. They purchased the former Baptist meetinghouse, moved it to the site, and outfitted it for business. In 1874 Virgil S. Pond became the sole owner. The Pond mill, using steam power, was one of the first to gain independence from having to be located on a stream or at a dam.

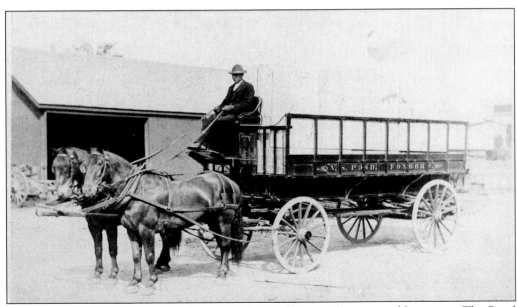

At one time every business owned horses and virtually everything moved by wagon. The Pond mill supplied boxes for the straw hat industry to facilitate shipments around the world. Elmer Davis was the teamster for the Pond mill.

The elegant home of Virgil S. Pond was located on Main Street. Originally, the structure had a flat roof to collect rainwater. Following a fire in his box shop in 1876, Virgil Pond became active in improving fire protection and the water supply. He was instrumental in forming the Foxboro Water District, and he added a third story to his home once water service was available.

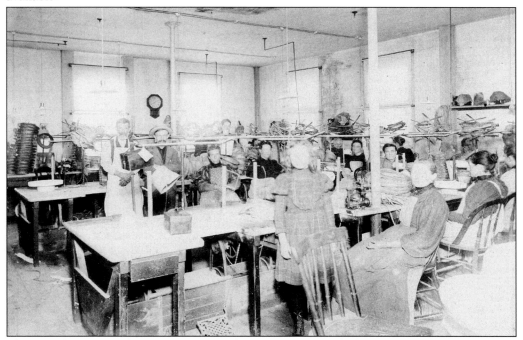

These workers are in the sewing room of the Caton Bros. Bixby hat factory. The straw hat era provided an opportunity for large numbers of women to work for wages. The factory rooms were generally well lit and airy, and the women became socially active in the community, supporting local events and organizing patriotic gatherings.

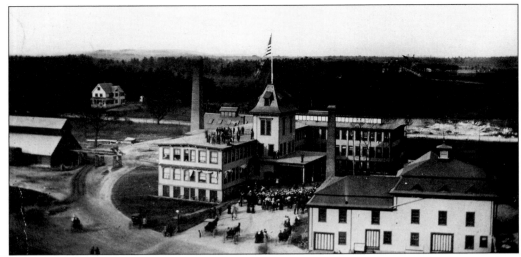

The Caton Bros. Bixby complex at the foot of Bird Street, located in what is now the Foxboro Company parking lot. Caton, Heckle & Co. was burned out in Boston and encouraged to come to Foxborough in 1884, using buildings of the south branch of the Union Straw Works on Water Street. The company reorganized as Caton Bros. Bixby in 1888 and moved into this complex a year later. The building in the foreground housed the Ryan & Sumner Grain Mill in the 1870s and became the Ryan Cider Mill in 1882.

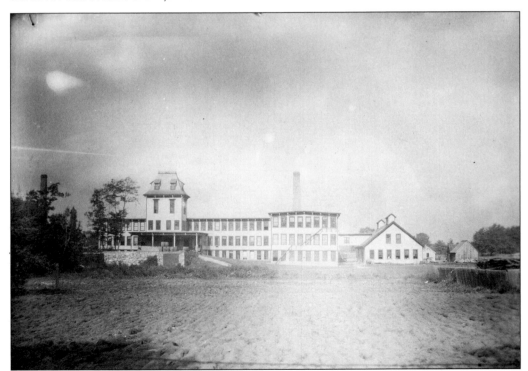

Another view of the Caton Bros. Bixby complex. The Caton brothers were William, Edward, and Thomas of Luton, England. They attracted many English workers, which influenced the start of the Episcopal Church in Foxborough. The factory was destroyed by fire in 1923.

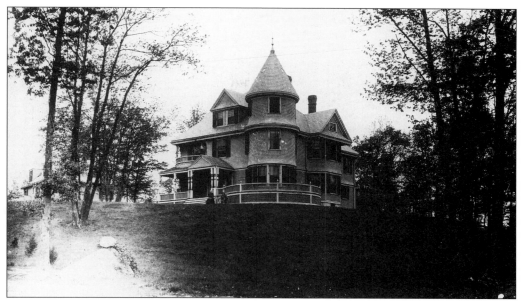

The home of Edward Caton, built on Maple Avenue, was located immediately behind the home of Mr. Bixby. Thomas Caton built an elegant home at the corner of Baker and Bentwood Streets that has since been converted to apartments. William Caton purchased the former Fountain Court at 17 Cocasset Street.

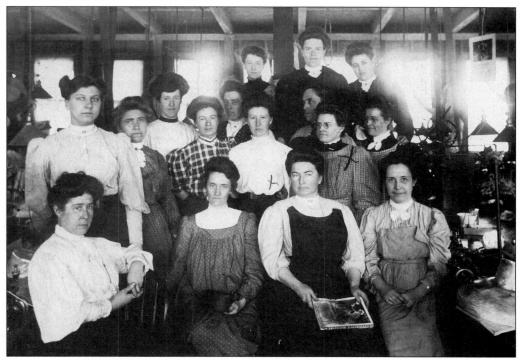

History has failed to preserve their names, but women like these working at the Caton Bros. factory were the mainstay of the straw hat industry. Many of them were attracted to Foxborough by the exceptional employment opportunities.

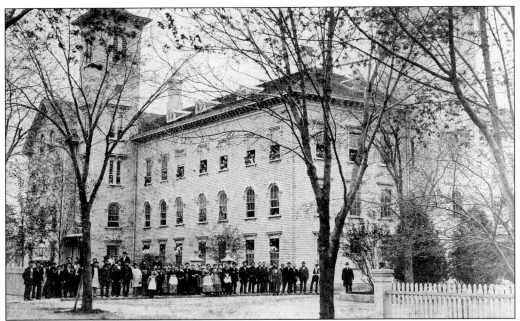

The Union Straw Works on Wall Street was the world's largest straw hat manufacturing business and employed 6,000 people at its peak. The business was started as the Great Bonnet Shop in 1844 by Oliver, Erastus, and Warren Carpenter (who donated the organ for the new Congregational church in 1854). By 1855, the business expanded and the Union Straw Works was built.

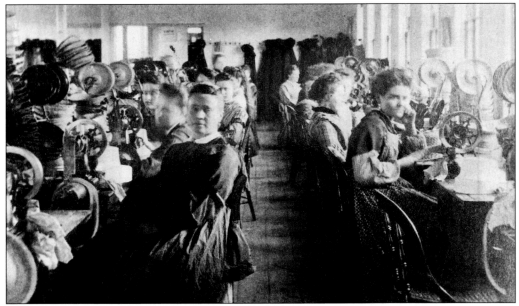

These ladies are working in the sewing room of the Union Straw Works. So many women were drawn to Foxborough for employment, the original buildings across the street from the factory— the Verandah House and the Hamlet House—were turned into boarding houses for female workers.

The home of E.P. Carpenter was located at the corner of Central and Liberty Streets. E.P. conceived the idea of uniting many of the small straw manufacturing companies into the Union Straw Works. He served on the committee to erect Memorial Hall following the Civil War, the committee to build the Town House in 1857, and headed the Sylvanian Association, which laid out and beautified the Common that same year.

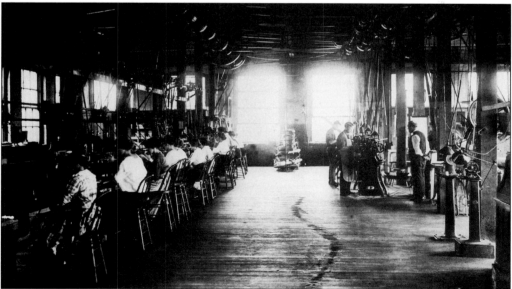

This work room in the Union Straw Works was typical for its time. In addition to those who worked in the factory, there was a large "cottage industry" where women braided and sewed straw at home. The women in the factory were socially active, raising money to purchase the gates for Rock Hill Cemetery. They also put notes of support and encouragement in hats being made for the troops during the Civil War.

41

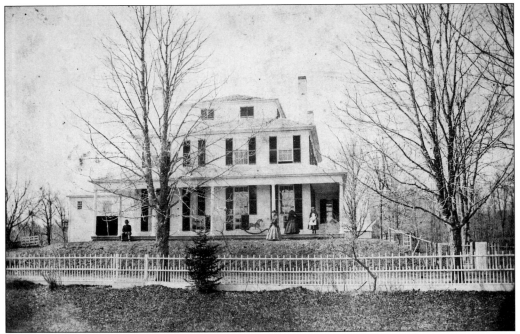

The home of Daniels Carpenter on Main Street has since been converted to apartments. A principal in the Union Straw Works and the father of E.P. Carpenter, Daniels introduced the manufacturing of spool cotton in America in 1832 and also pioneered the use of steam in straw manufacturing. He was a veteran of the War of 1812.

Another view of the Union Straw Works. The company built a stone reservoir behind the present Town Hall; a windmill provided power to pump the water into the stone structure, and then gravity fed the water to the factory on Wall Street. The company also produced its own gas for illumination and constructed its own sewage-disposal system.

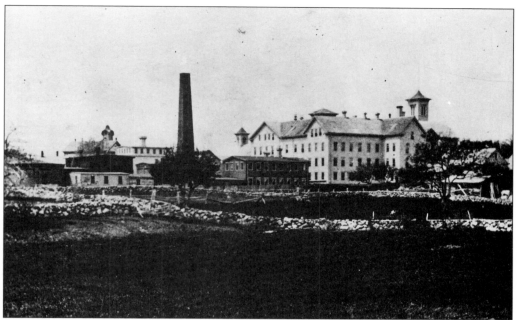

The factory, mostly of wood-frame construction, stretched for more than 1,000 feet from Wall Street. A row of small duplex houses was built on Sherman Street which provided housing for many of the workers. Many stately homes in the community were built by USW workers and management. Employment was steady, and the company pioneered benefits such as bonuses and paid vacations.

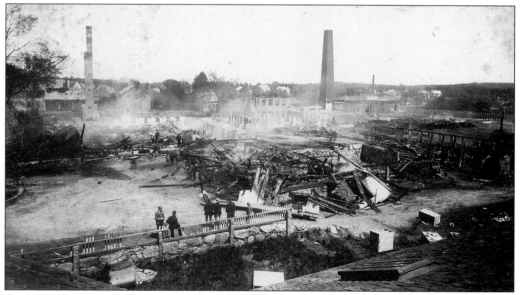

On May 28, 1900, at about 7 pm, fire struck. The sprawling Union Straw Works was totally destroyed in ninety minutes. An additional pumper was put on a flatbed railroad car in Taunton and rushed to the scene to assist local firefighters, but it was a futile effort. The fire spread so quickly, there was little that could be done. The company that had done so much for so many was gone.

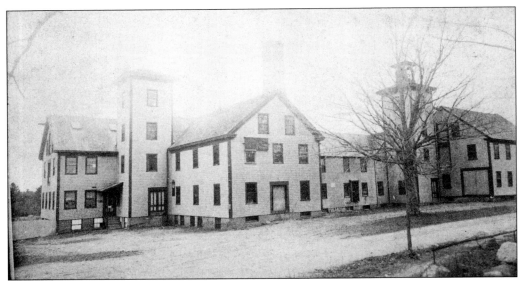

This sprawling complex on Water Street was started in 1812 by Squire Elias Nason as a cotton mill. It is seen here as the National Fibre and Chemical Works. Over the years, it was used to manufacture cotton, straw hats, soap, fibre products, and leather goods. It had fifty-nine owners or prime tenants in its ninety-three-year history before burning to the ground on July 4, 1905. For many years, it was the south branch of the Union Straw Works (p. 40), and the Caton Bros. hat business (p. 38) occupied the building when the business first moved to Foxborough.

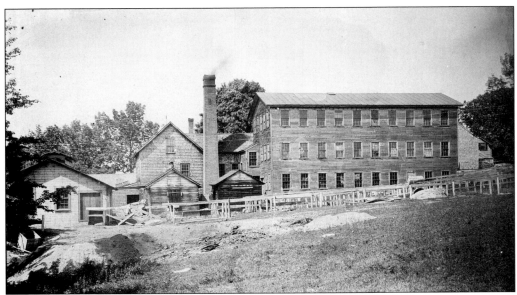

Young's Dye House was built by Asa Young and his son Arthur in 1885. When the original building was nearing completion, the success of the business necessitated an addition which nearly doubled its capacity. It was located on the present Stilwell property at the corner of Granite and Prospect Streets.

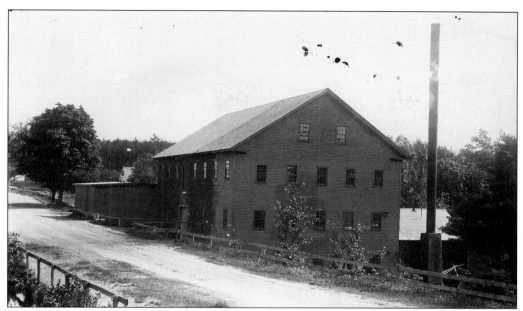

The Ross Scouring Mill at Lakeview was built on the site of Deacon Harvey Pettee's stone thread mill. Lakeview was created to hold water for manufacturing purposes. The building burned in 1876 and was replaced. A flood in 1886 tore away the dam and ripped the end off the building. It was repaired and work resumed, but when it was destroyed by fire a second time, it was not rebuilt.

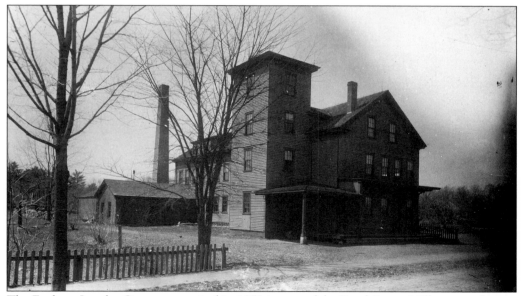

The Foxboro Jewelry Co. was organized in 1852 in part of the Pond Steam Mill to manufacture gold jewelry. Owners Carmi Richmond, Daniels Carpenter, Charles Downs, Joseph Downs, and Major Monroe then erected this building on Main Street in 1856. It would later be used by the Rotary Shuttle Sewing Machines Co. (one of the machines is displayed at Memorial Hall), as Faught's Straw Works, and as the west branch of the Union Straw Works. It is now owned by the Sentry Company, which manufactures heat-treating furnaces for industrial use.

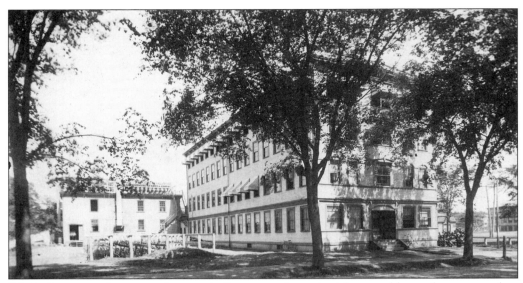

Edwin Rogers, a shoe manufacturer in Lynn, was beset by labor troubles and encouraged to move to Foxborough by the Bay State Improvement Association. He erected this building at the corner of Bird Street and Railroad Avenue in 1886. He sold out to the Bay State Boot and Shoe Company, which closed in 1891. In 1894 the building became the Inman & Kimball hat factory. William Kimball served as selectman, tax collector, and school committee member and, shortly before his death in 1935, was postmaster.

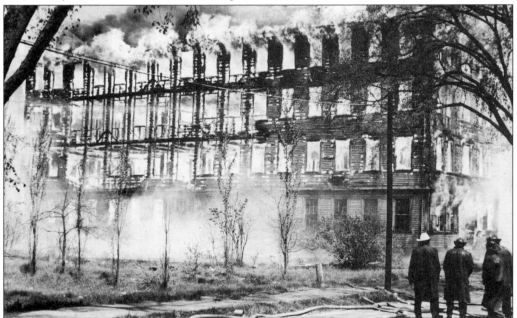

Inman & Kimball prospered for a time and used the old west branch of the Union Straw Works on Main Street for additional space. By the mid-1920s, however, business was declining due to competition from New York and western manufacturers. The building was empty in 1936 when it was destroyed by fire in a spectacular midday blaze. The corner is now a lovely park maintained by the Doolittle Home for its elderly residents.

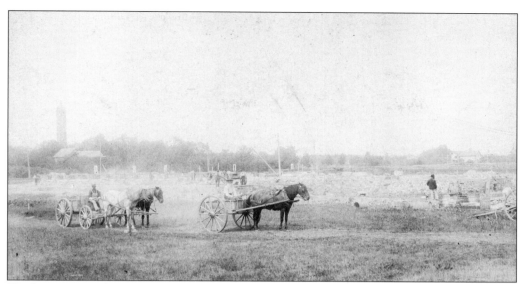

Work commenced in 1894 on a huge complex of brick buildings on Neponset Avenue for the Van Choate Electric Company. Van Choate held patents for making electrical devices and held out the promise of many jobs. The town laid out streets and sidewalks and many local residents purchased stock. Very little was manufactured, however, before the company went into receivership on February 2, 1900.

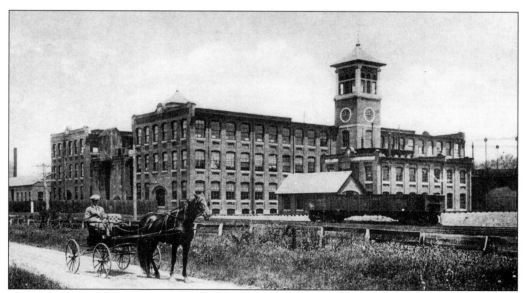

Bennett and Edgar Bristol, breaking away from the family business in Connecticut, formed the Industrial Instrument Company and later purchased the Standard Gauge Manufacturing Co. of New York. In 1908, they purchased (for $65,000 cash) the complex of buildings on Neponset Avenue erected by Van Choate. In 1914 they changed the name to the Foxboro Company. The company grew to include manufacturing facilities in eight nations and had sales offices in every country in the free world. The Foxboro Company is now a division of the Siebe Corporation.

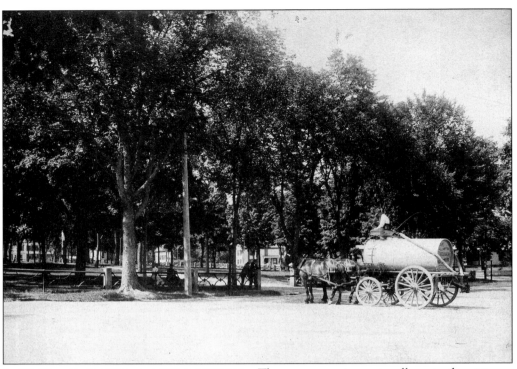

The town watering cart pulls up to the cistern at the foot of the Common for a refill, *c.* 1900. The dirt roads of the community were sprinkled with water to hold down the dust, especially on wash day, when most homemakers would have the week's laundry hanging on the clothesline in the back yard.

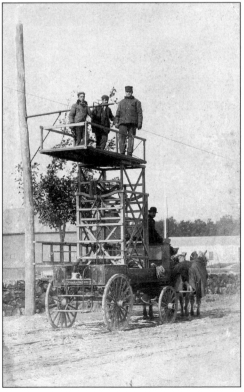

Workers used a fixed platform in the back of a wagon to tend the electric lines which powered the "Electrics." The trolley line ran from Norwood to Mansfield and passed through Foxborough on North, Main, and Central Streets. The workers have been identified as Frank Carpenter (left), David Burke (center), and Edwin Morton (right). The driver is John Kirby.

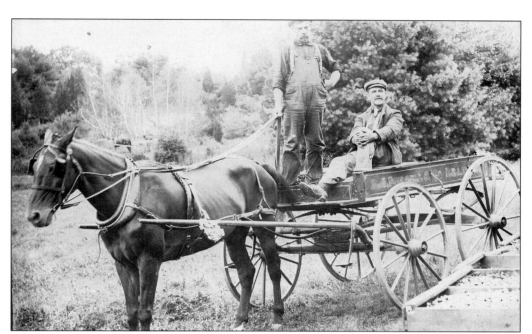

These workers are hauling cranberries from Paradise Meadow on the Foxborough/Sharon town line in 1910. The bog was operated by members of the Turner family (p. 17). The back of the photograph identifies the workers as "Mr. Hofflin of W. Mansfield and myself," with no indication as to whom "myself" might be.

Fame also escapes our cover subject, who remains nameless. The railroad line through the center of town carried considerable freight, as most of the goods manufactured here moved by rail. Directories of the day list many workers as boarders in various homes. Some railroad workers also lived on the third floor of the depot (p. 62).

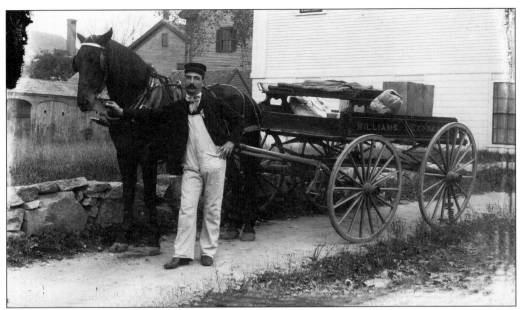

Williams Express and Stage wagons were a familiar sight in the vicinity of the depot and various factories. An 1863 ad in the *Norfolk County Chronicle* notes they met three Boston passenger trains daily in East Foxborough and would provide transportation to the center of town.

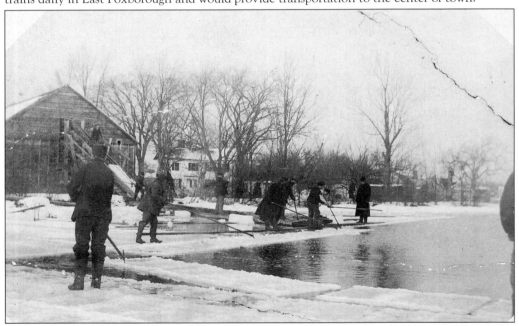

Cutting ice was an essential activity in the days before electric refrigerators. A. Bisbee had a business on Water Street with an ice house on the Stilwell property on Cocasset Lake. William Castillo, operating in East Foxborough, posted 4,000 tons of ice in 1885. Ideal cutting was when the ice was 10 to 14 inches thick. During mild winters, the prices soared as local dealers sought supplies elsewhere. Activity on Smith's Pond (now VanDenBerghe's) continued into the early 1940s, by which time the horse and wagon had given way to motorized vehicles.

Three
How They Played

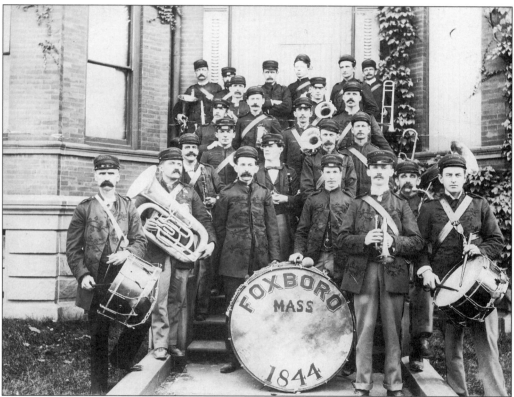

The Foxboro Brass Band was organized in 1844 and was an immediate source of community pride. E.C. Fales was the director, John C. Fisher the leader, and Merrick Torrey the clerk. An instructor was hired to teach members how to play instruments, and the first number performed in public was "Bounding Billows." Skilled musicians were also scouted, much like players for the semi-professional baseball leagues, and once one was located and enticed to come to Foxborough, the search was on for a job and a place to live. Seasonal fluctuations in the straw hat business dampened the recruitment efforts. The band performed for President Grant when he visited Cottage City on Martha's Vineyard and its presence turned most any community happening into a special event. When the 1872 Cole steamer, ordered for the local fire company, arrived at the depot, the Foxboro Brass Band was waiting, forming an impromptu parade as members accompanied the steamer to the fire barn. The band also performed at the centennial celebration in 1878.

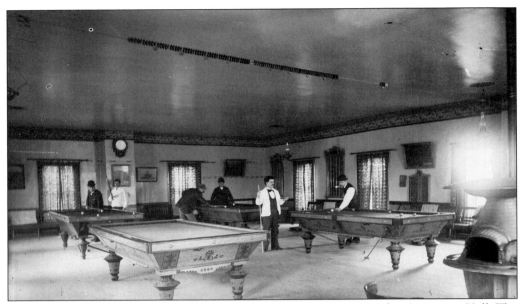

A billiard parlor was established at the American Club and then moved to Samaritan Hall. The parlor drew the wrath of those who foresaw the damnation of youth by such a vice, while other letter writers to the local paper saw billiards as a game of great skill.

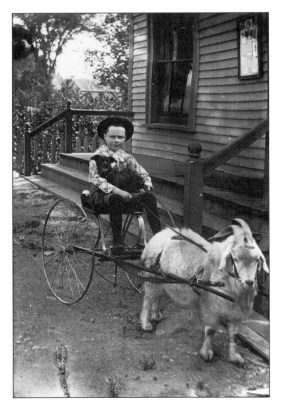

History failed to record his name, but this young man surely must have been the envy of the neighborhood with his goat-powered cart. He is shown here in front of the Stevens photo studio, on the discontinued portion of Centennial Street which was absorbed by the BayBank parking lot.

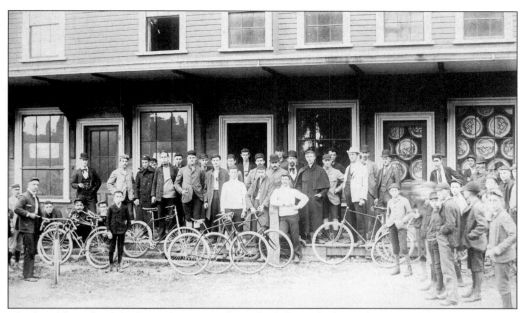

The local bicycle club, formed in 1890, flourished through the early years of the next century. Meetings were held for a time at the East India Tea Company on Wall Street, which later became the Foxboro Coal Co. and then Grossmans. Adding a competitive edge to their hobby, club members challenged the Mansfield Wheelmen to a race in 1891, using the trotting track at Cook's Farm for the meet.

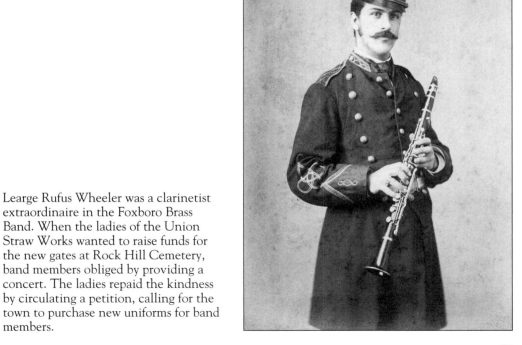

Learge Rufus Wheeler was a clarinetist extraordinaire in the Foxboro Brass Band. When the ladies of the Union Straw Works wanted to raise funds for the new gates at Rock Hill Cemetery, band members obliged by providing a concert. The ladies repaid the kindness by circulating a petition, calling for the town to purchase new uniforms for band members.

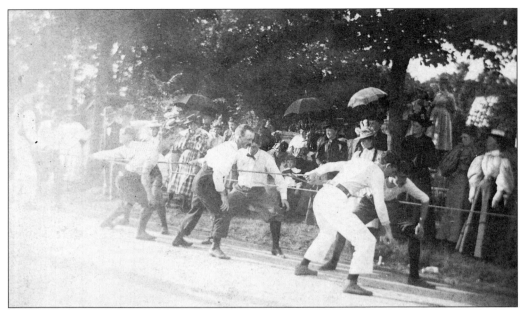

A spirited tug-o-war was part of the field day events held for many years, first by the Foxboro Fraternity and later by the Foxboro Fire Department. The highlight of the community social calendar in summertime, the Firefighter's Field Days have since been replaced by Founders Day, celebrated on the Saturday closest to June 10 (the day Foxborough was incorporated) each year.

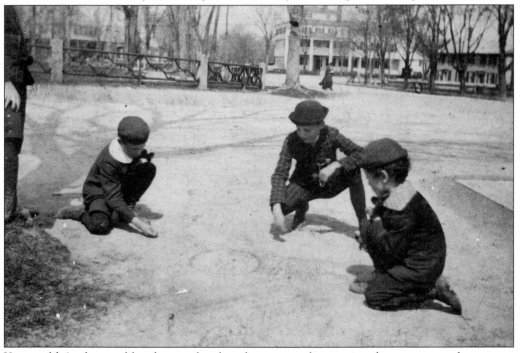

You couldn't play marbles there today, but these young boys enjoyed a game near the present traffic triangle across from Memorial Hall. Immediately to the right is the edge of the town scale on which farmers were able to weigh huge loads of hay.

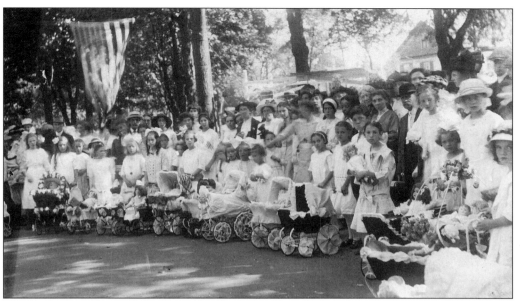

The Doll Carriage Parade is another reminder of the Firefighter's Field Days.

Who knows what mischief they were up to? This photograph appears to have been taken on Central Street, in the vicinity of the Hedges residence. With their picnic basket and a few bottles of spirits, dressed as scarecrows, it does cause one to wonder.

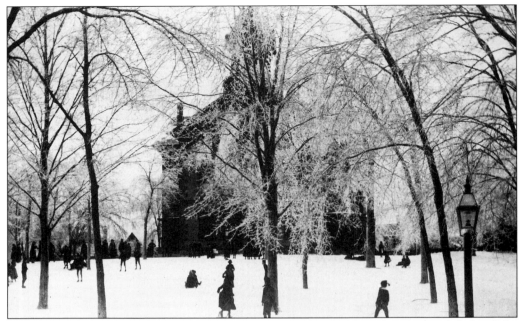

An afternoon of sledding in the front yard of the Town House, located immediately behind the present Town Hall. For many years, the town blocked off a section of Granite Street in Happy Hollow to create some of the finest sledding around.

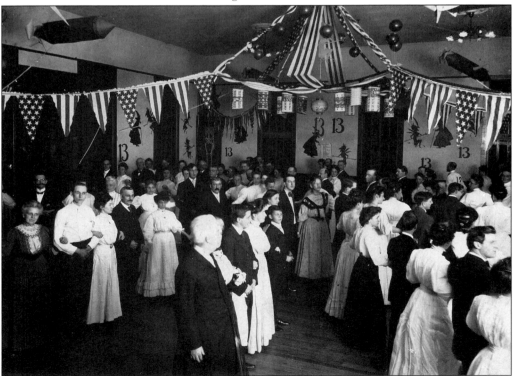

Members of the Friday Night Club went all out when Friday fell on the 13th in 1907.

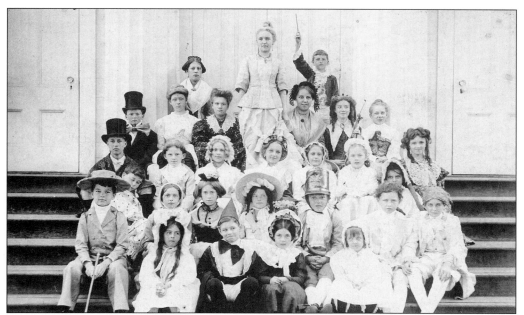

The "Ye Little Olde Folks Concert" featured, from left to right: (front row) Madeline Coombs, Sheldon Coombs, Gladys Cady, and Mabel Torrey; (second row) Willard Wyman, Ralph McNary (the sleepy cherub), Lesley Coombs, Lillian Huntress, Anna Torrey, Wesley Mott, Albert Coleman, and Milton Whyte; (third row) Merton Wilmore, Ralph Hearn, Olive Sawyer, Barbara Hedges, Marie Merz, Ruby Shaw, Gladys Morse, and Doris Coleman; (fourth row) Rea Potter, Eva Francis, Leola McKenzie, Ella Wood, Annie Belcher, Mabel Cook; (back row) Vina Dix, Edith (Mott) Lane (coauthor of *This Was Foxborough*), and Edward Potter.

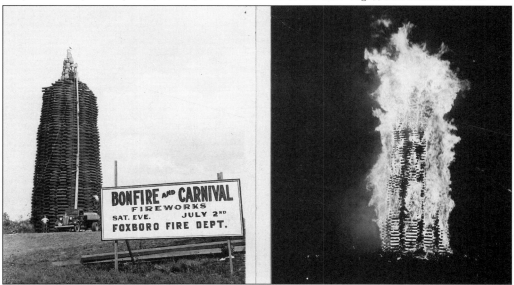

The excitement would build for weeks as firefighters piled the wood higher and higher. On the appointed day, young children would try to nap in the afternoon so they could stay up late into the night watching the bonfire on the far side of Robinson Hill which signaled the end of the Firefighter's Field Days for another year.

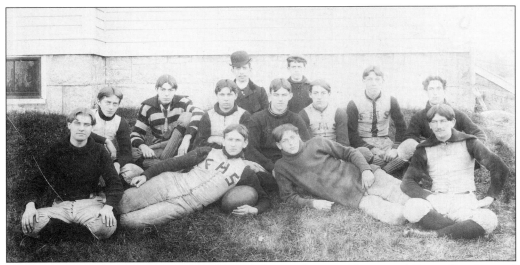

The FHS football team, about 1903. From left to right are: (front row) Lewis Boyden and Willard Gould; (middle row) Emory Gorham, Clifford Lane (coauthor of *This Was Foxborough*), Cheney Wilbur, Charles McTernan, Elliot Goodnough, Dana Wilbur, Shepard Wilbur, Charles Dow, and Arthur Troyes; (back row) manager Harry Sweet and assistant manager Ralph Boyden. The team, which had no substitutes, was undefeated and untied playing Walpole, Canton, Stoughton, Mansfield, and two games with Attleboro.

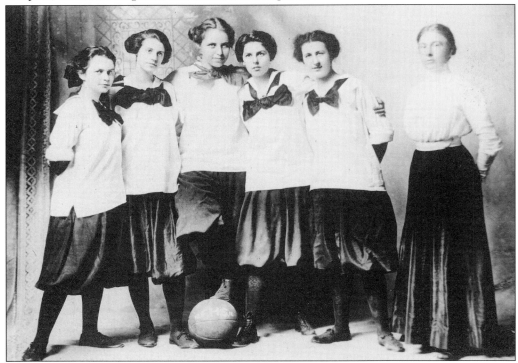

These young women were the Norfolk County Girls Basketball Champions from 1909 to 1911. The team members, from left to right, are Billie Harris, Catherine Carpenter, Ella Wood, Maud Alexander, and Pearl Pettee. The coach, Mrs. Harding, is on the right.

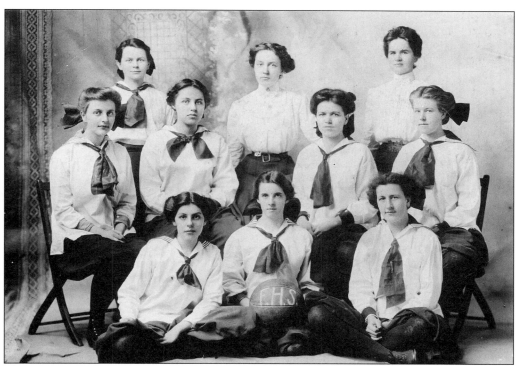

The 1910 Foxboro High School girls basketball team pose for the camera.

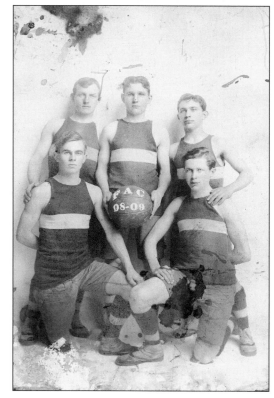

The members of the 1908–1909 Foxboro Athletic Club basketball team were, from left to right: (front row) Ray Leonard and Vic Carpenter; (back row) Wes McGlory, Frank Ryan, and Jim Ryan.

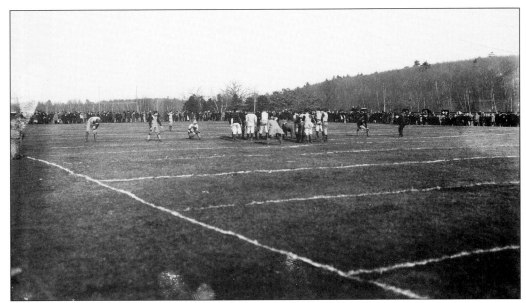

While Foxboro High School students attended classes at the Center School (between the burning of the Town House in 1900 and the opening of the new high school in 1928), athletic encounters were relegated to the field on the far side of Robinson Hill behind the present row of houses on Central Street.

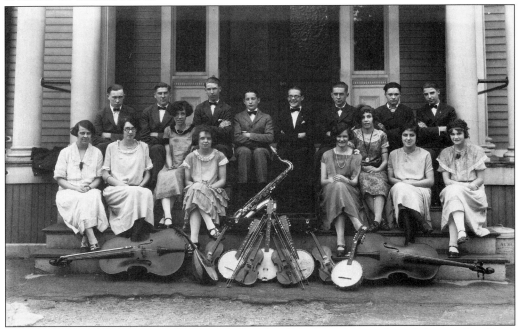

The members of the 1924–25 Foxboro High School Orchestra were, from left to right: (front row) director Louise Prescott Inman, Agnes Devine, Vivian Parsons (Lucas), Elizabeth Gilchrist (Moffa), Ruth Richards (Stripp), Loa Brown (Giles), Patricia Lewis (Hicks), and Martha Ingalls; (back row) Bernard Devine, Lloyd Carpenter, Norman Blaisdell, ? Nevers, William Lawson, Clifton Guild, Donald ?, and Delos Brown.

Four
How They Traveled

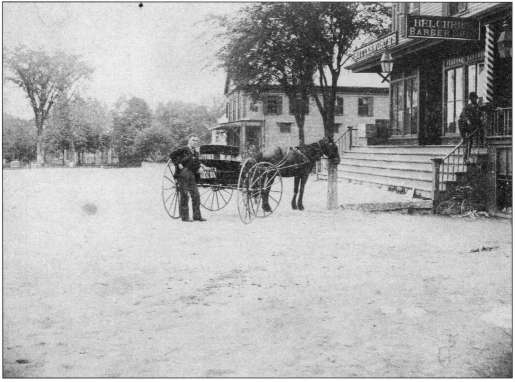

For many families in early Foxborough, getting a haircut for the gentleman or picking out a new hat for the lady meant hitching up the horse and wagon for a trip to Belcher's Barber Shop or Butterworth's Store on School Street in the center of town. Most families, especially in the outlying districts, had horses. So did most every business that had to ship goods. In addition, there were stage lines, livery stables, and haulers to satisfy other needs. The town had horses for working on the roads, pulling fire apparatus, and hauling barges loaded with children to the center of town for school. There was no question: the horse was a necessity for those living in the village.

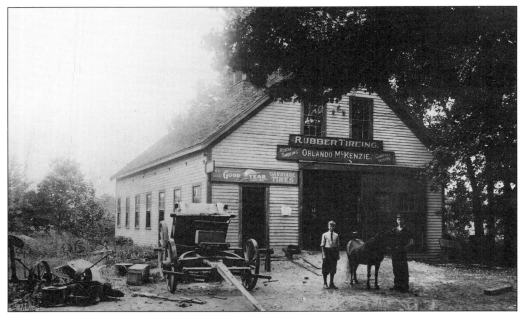

Orlando McKenzie's blacksmith shop on Central Street later became a large automobile dealership. Orlando came to Foxborough in 1905 (p. 31) and served as a town and state official. The man holding the horse is James McIntosh; the young boy is Harold E. McKenzie.

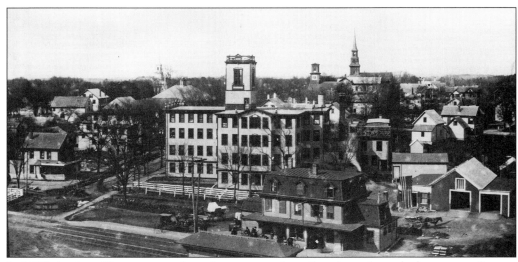

In 1869 the Iron Horse appeared on the scene as the railroad cut through the center of town. The depot, at the foot of Bird Street at Railroad Avenue, was once a coffin shop. It was moved to the site and a third floor was added. The Williams Coal Co. also had a building in the depot complex. The large factory shown here is the Inman & Kimball Hat Shop (p. 46). The first train car to pass between Mansfield and Foxborough arrived on September 18.

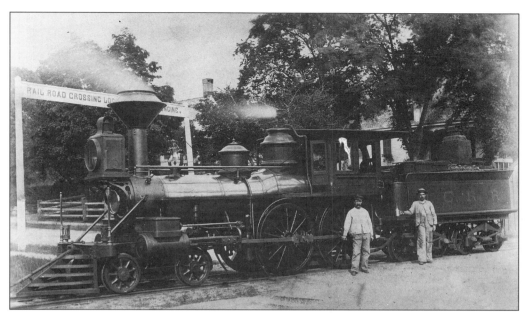

This is a view of the Mechanic Street railroad crossing. The Foxborough Branch Railroad was organized in 1861 by local business interests, including Otis Cary, Willard Manuel, E.P. Carpenter, J.E. Carpenter, and Virgil Pond. The name was changed to the Mansfield & Framingham R.R. in 1867 and it eventually became the Old Colony. The first train ran in 1869; a second track was laid in 1885.

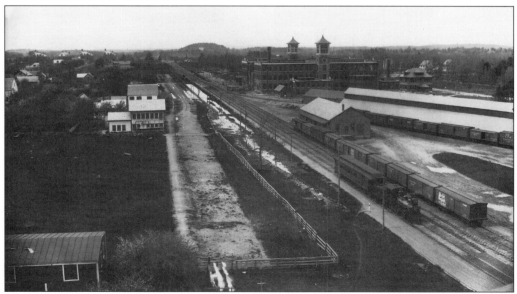

Six spur lines swung off from the double track into what is now the Foxboro Company parking lot. Huge sheds stored goods to be moved by train and an elevated trestle allowed coal cars to be pushed up the ramp to dump their loads. The large white building in the left center of the photograph was the photography business of Frank Pond (p. 23). The building was later converted to a dwelling. The fence prevented the town from building Railroad Avenue until a dispute with the railroad was settled (p. 65).

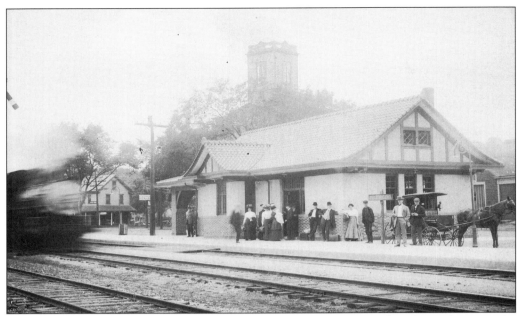

The second depot was located at the foot of Bird Street. When it was phased out of service, the building was dismantled. Bob Campbell salvaged the chestnut wood interior for his residence on Pleasant Street.

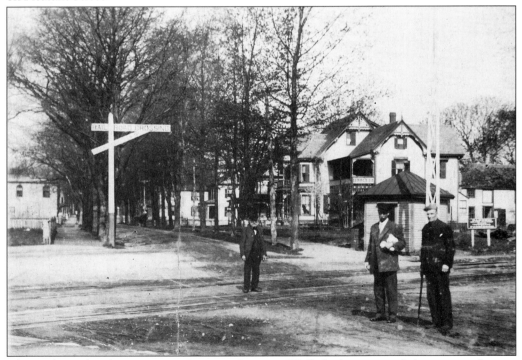

This is the railroad crossing on Cocasset Street at Wall, looking toward the center of town. Each crossing had a small gatekeeper's building which was staffed around the clock. In the heyday of the railroad, more than 1,000 railroad cars passed over this line daily.

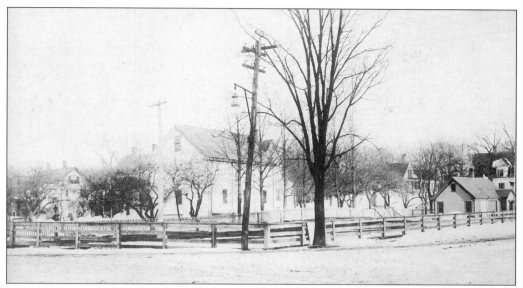

In order to lure the Van Choate Electric Co. (p. 47) to Foxborough, town officials made many commitments relative to roads, sidewalks, lighting, and shade trees. One road was to run from Mechanic Street through the railroad land and across the station grounds. Railroad officials objected, and in 1895 they erected the "Spite Fence" across their property to curb the town's plan. The courts and state legislature got involved, but local business interests prevailed, and the railroad removed the fence in 1907. The street was built and appropriately named Railroad Avenue.

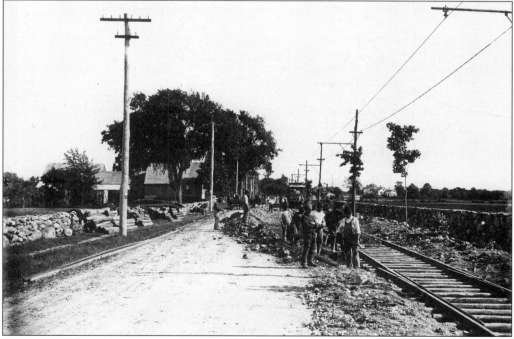

But what is this? More tracks, this time down on Central Street, for the Norfolk Southern Electric R.R., which would eventually run from Mansfield through Foxborough to Norwood.

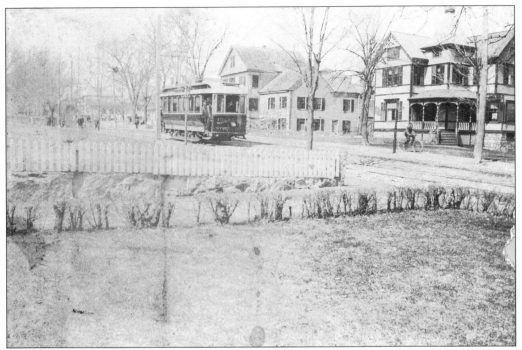

At 1:30 pm on Saturday, April 8, 1899, the first electric railway car passed through the center of Foxborough, ushering in a new age of public transportation. On the first full day of operation, the line collected 1,260 fares as people tried out the new novelty.

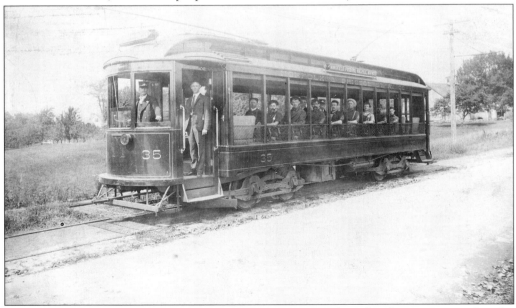

Undergoing a financial reorganization after seven months, the line came under the management of Francis Munroe Perry (standing in the doorway), who would also bring Foxborough its first motion pictures. The line extended a branch to Lakeview and the Lane property to make summertime recreation activities more accessible.

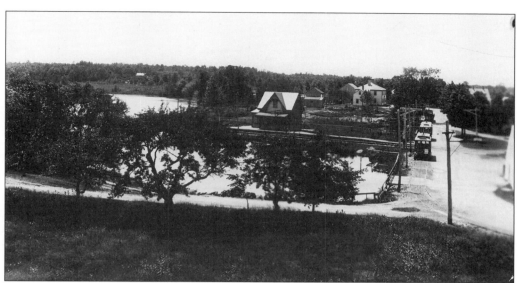

The electric trolley line lacked the technology to cross the railroad tracks at North Street, so two cars had to be scheduled to meet there so passengers could disembark, walk across the tracks, and board the second car to continue the journey. This was costly in terms of manpower and equipment, and was an inconvenience to patrons.

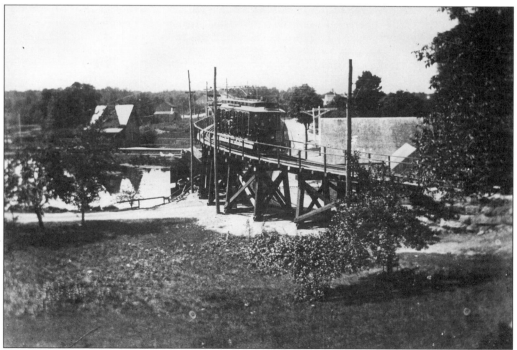

The solution was to build a 467-foot-long, 18-foot-high wooden trestle to allow the trolley to pass over the railroad track for an uninterrupted journey. Declining revenues and labor disputes plagued the line. The workers made specific demands with a deadline of midnight, August 15, 1919; the deadline passed without response, and the trolley never ran again.

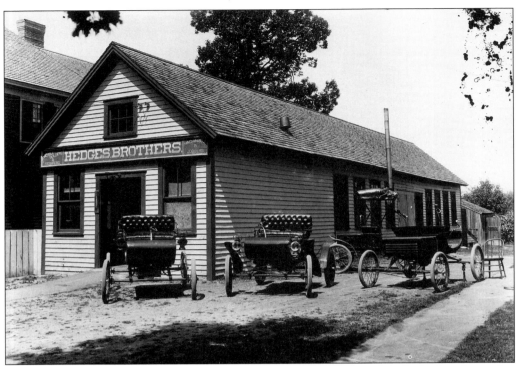

The new century brought Hedges Brothers, Foxborough's first automobile dealership, located at 94 Central Street, which played a role in the demise of the trolley line and contributed to the changing face of the community.

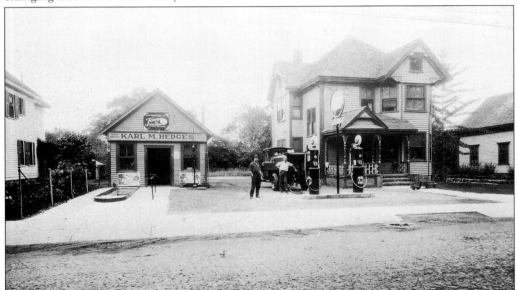

And if you have an automobile dealership, can the first service station be far behind? They also did repairs, and had an outdoor pit in which the mechanic could stand to work under the vehicle. The Hedges family rode the crest of the wave of change in the days when $1 for gas would keep a young man driving all week long.

Five
How They Provided

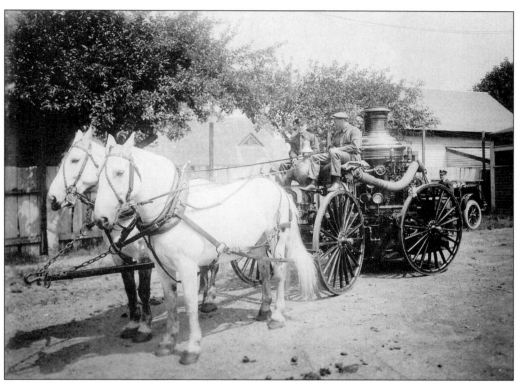

The pride of the community, the Cole steamer was purchased in 1872, and was much more capable than the small pumper acquired in 1851. The early fire company was a private effort, organized by businessmen who could not protect their property without adequate water supplies (p. 74) and fire protection. But fire protection was not an exact science. When the alarm sounded for a fire in a store at the head of the Common, the town's two horses were released from roadwork to make their way to the station to pull the steamer. In the meantime, a fire had been lit under the boiler of the steamer to build up a head of steam. But as the huge apparatus bumped over the dirt roads in the center of town heading to the fire, hot embers bounced out the back and were picked up by the wind. Soon, five other buildings were on fire, and the lowly pumper was pressed into service as "the little engine that could." The fires were eventually extinguished.

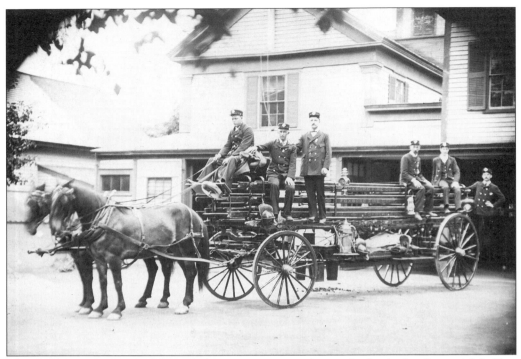

This ladder wagon existed long before anyone even dreamed of a hydraulic aerial ladder. Firefighters practiced continually to maintain proficiency in handling the ladders, and often tested their skills in competitive musters against other departments.

The chemical wagon was added for more specialized protection. In 1932, the Fire Company was disbanded and the department officially became the Foxboro Fire Department. The two original pieces of equipment, the 1851 pumper and 1872 steamer, have been preserved and are on permanent display in the Steamer Shed behind Memorial Hall.

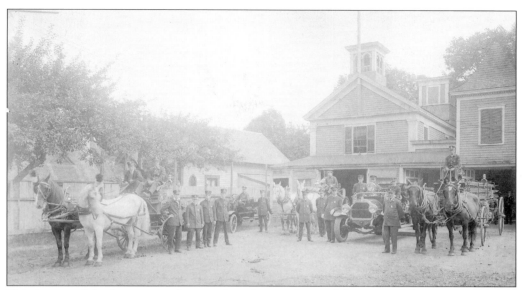

This is one of the last group photographs taken in front of the original fire station, located behind the Town Hall. The first motorized equipment was Combination No. 1, purchased from Maxim Motors in May 1917. The last pair of horses used for pulling the steamer to fires was sold about 1923. The steamer was still used for a few more years, being pulled to the fire by a truck, but eventually it was retired from service.

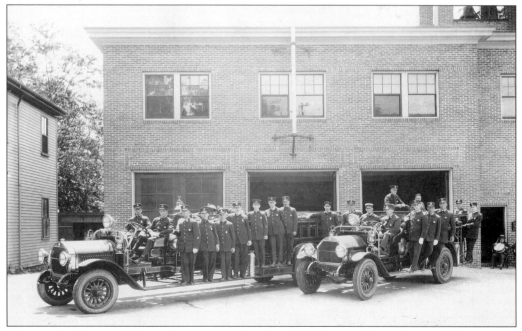

The new (and present) fire station was completed in 1925 for a totally-mechanized department. In 1939, department members purchased a panel truck and equipped it for emergency use as the town's first combination ambulance and rescue vehicle. In 1948, the first aerial ladder was purchased, just in time to give the Class D championship football team and cheerleaders a ride around the Common in a victory parade.

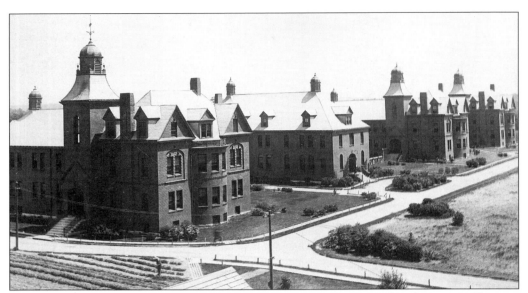

The Massachusetts Hospital for the Rehabilitation of Dipsomaniacs and Inebriates on Chestnut Street accepted its first patients in February 1893. The name was changed to the Foxboro State Hospital in 1905.

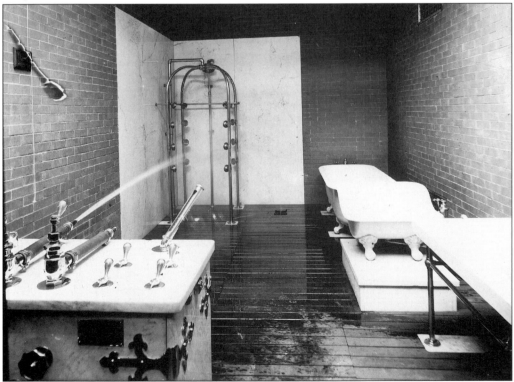

This is a state-of-the-art treatment room in the Foxboro State Hospital. As the hospital began accepting patients from the State Board of Insanity, the inebriates were moved to a new facility in Norfolk, which later became Pondville Hospital and is now Southwood Hospital.

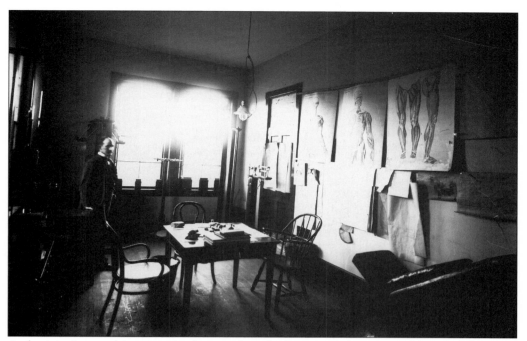

A physician's consulting room in the complex which now stands empty and boarded, facing an uncertain future after the state stopped "warehousing" patients in favor of community-based programs.

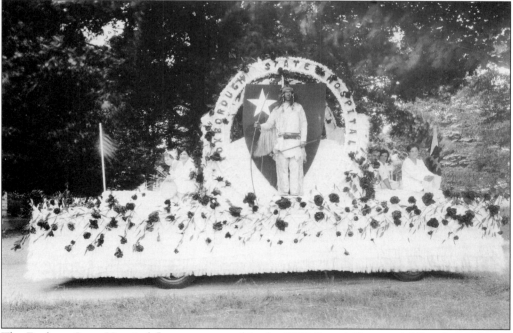

The Foxboro State Hospital float was entered in the 1928 Sesqui-Centennial Parade as a living state seal, and it won the judge's award. There was considerable interaction between the hospital and the community, with many volunteers conducting programs at the hospital.

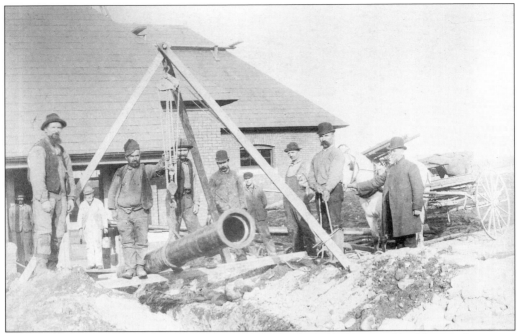

The need for a public water supply could no longer be denied. Continued building in the center of town endangered all the private water wells, and industry was hesitant to expand without adequate fire protection. As a result, a private water company was formed in 1891, and work commenced on the wells and pumping station off Chestnut Street.

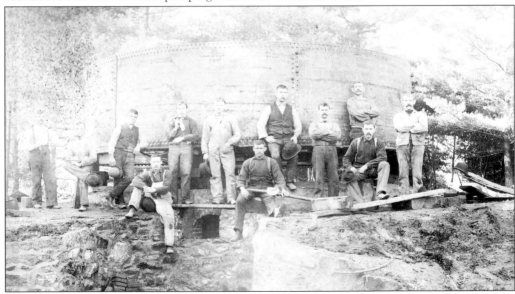

These workmen are erecting the standpipe (since removed) on Glenwood Avenue. The project had its detractors, and the rumor spread that once water was taken from the ground the center of town would sink. Many said they did not believe the rumor, but found it convenient to be out of town that day, just in case. In 1931, the Foxborough Water Supply District became an official department of the town.

Six
How They Worshiped

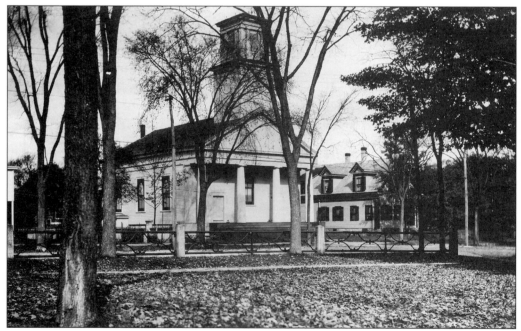

The Universalist church was erected in 1843 on land donated by Willard P. Turner. The Universalist Society was originally formed in 1837, meeting in Sumner Hall and the Union Building. The original spire fell in a gale of 1853, and the auditorium and organ were damaged by fire in the early 1860s. The Bible was rescued by Lewis Pond (p. 23).

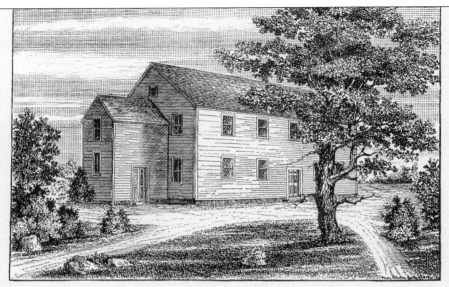

The Old Foxborough Meeting-House. Page 244.

1. Minister's Pew.
2. { Dr. Joshua Wood.
 Capt. Geo. Stratton.
3. Job Sherman.
4. Dea. Samuel Baker.
5. John Comey.
6. Dea. Isaac Pratt.
7. Jacob Leonard.
8. Seth Boyden.
9. Richard Everett.
10. Dea. Spencer Hodges.
11. Ephraim Shephard.
12. { John Sumner.
 Dea. Ebenezer Forrist
13. Amos Morse.
14. { William Paine.
 Otis Paine.
15. Asa and James Paine.
16. Seth Robinson.
17. Francis Daniels.
18. John Sumner.
19. { Nathan Clark.
 Lewis Leonard.
20. Asa and Elijah Plimpton.
21. { Jacob Shephard.
 Elias Nason.
22. Abijah Pratt.
23. John Hewes.*
24. Swift Payson, Esq.
25. { John Carpenter.
 Meletiah Everett, Esq.
26. Jesse Hartshorn.
27. Seth Robinson.
28. { Preston Shepard.
 Noah Hobart.
29. Eleazer Robbins.

30. { Benjamin Pettee.
 Amos Boyden.
31. Zadok Howe and Job
 Willis.
32. Dea. Aaron Everett.
33. Seth Robinson (family
 pew.)
34. Capt. Oliver Comey.
35. { Dea. Nehemiah Carpenter.
 Ezra Carpenter.
36. { William Clark.
 Hezekiah Pettee.
37. Hon. Ebenezer Warren.
38. { Major —— Billings.
 David Morse.
39. { Maj. Joseph Shepard.
 Metcalf Everett, and
 Francis Jones.
40. William Sumner.
41. { Dea Nathaniel Clark.
 Ethridge Clark.

Gallery.
1. Ezra Carpenter.
2. John Carpenter.
3. —— Paine.
4. Stephen Boyden.
5. Roger Morse.
6. William Sumner.
7. ———— ————
8. ———— ————
9. Jesse Hartshorn.
10. Beriah Mann.
11. Jairus P. Morse.
12. Roger Sumner.
13. Elias Guild.

* No. 23 was finally owned by Dea. Stephen Rhodes, and was the first pew removed when the building was taken down.

A. Men's porch. B. Women's porch.
C. Pulpit, with Deacon's seats and communion table in front.
D. The seats at D were replaced about the year 1816, by four pews marked 25, 26, 27, and 28 in the list of pew owners.

Floor Plan.

The Meeting House on the Common was erected in 1763 and removed in 1822. Each area was required to have a meetinghouse before it could be incorporated as a town. Families erected the building at their own expense in anticipation of becoming a town. Their petition was repeatedly denied until June 10, 1778. The early families which paid for pews are listed.

The Congregational church was the successor to the Meeting House on the Common. "Bethany" was added to the name in 1894. The Congregational Society began in 1779 in the Meeting House and built the first formal church—the brick church—at the head of Rockhill Street in 1822 when the Meeting House was torn down. Pews from the Meeting House were carried to the brick church, and bricks from that building formed the foundation of the present edifice, erected in 1854.

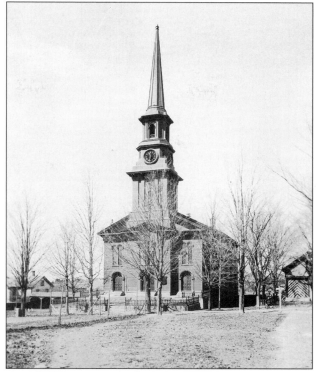

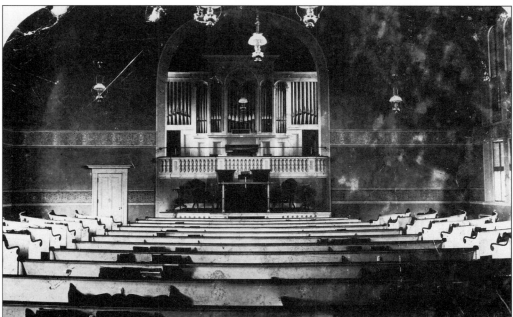

An early view of the interior of the Congregational church of 1854. The handsome pipe organ was a gift of Warren Carpenter, a principal in the Union Straw Works. The organist was Franklin Pettee. Note the oil lamp fixtures hanging from the ceiling, which could be pulled down for lighting and extinguishing.

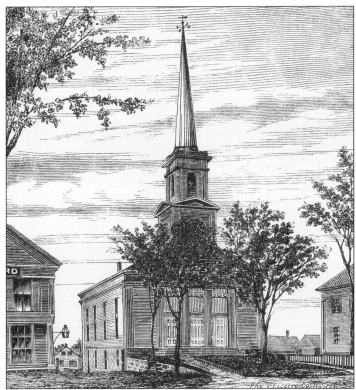

The second Baptist church was erected in 1850 facing the Common. It was removed for the construction of BayBank. The first Baptist church (1822) was on Elm Street, which at that time was the main route to Mansfield, since the upper portion of Central Street had not yet been built. The church was later moved to the center on the lot presently occupied by the Town Hall. When a new church was built facing the Common in 1850, the original church building was moved once more, this time to Virgil Pond's mill on Market Street. It later burned.

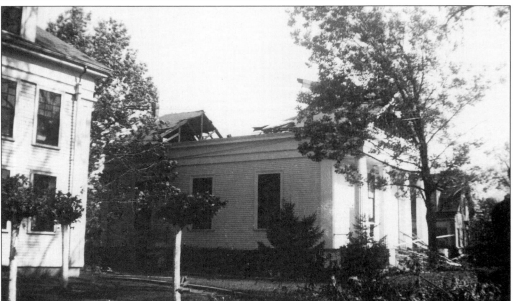

The Universalist church is the oldest house of worship in the community, but it was heavily damaged in the hurricane of September 1938. What remained of the spire was tossed back and forth in the wind until the supporting timbers were weakened. The tower then fell straight down through the sanctuary, causing heavy damage.

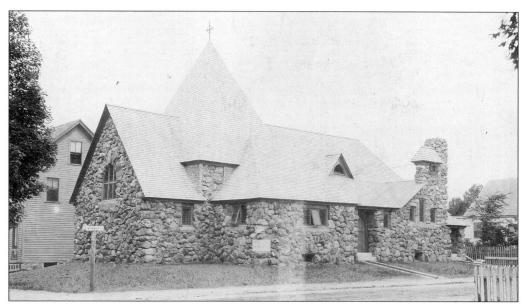

The Episcopal church was erected at the corner of South and Market Streets in 1893. The building is now the home of the Lutheran Church of Our Redeemer. The Episcopalians erected a new structure on South Street. Many Englishmen of the Episcopal persuasion were attracted to work at the Caton Bros. Bixby factory (p. 38), helping to account for the growth of the church.

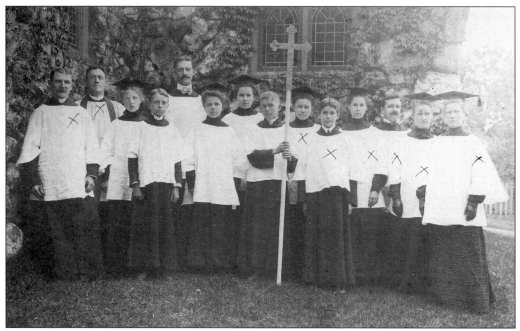

The consecration of St. Mark's Episcopal Church at the first worship service on May 31, 1894, was captured on film. The participants included Charles Clark, organist Clarence Foster, Reverend Mr. A. George, Ellen Greene, Lillian Abbott, Carrie Morse, Lawrence Inman, Fred Inman, John Howarth, Esther Woodbury, Stanley Atwood, and Miss Mary Spooner.

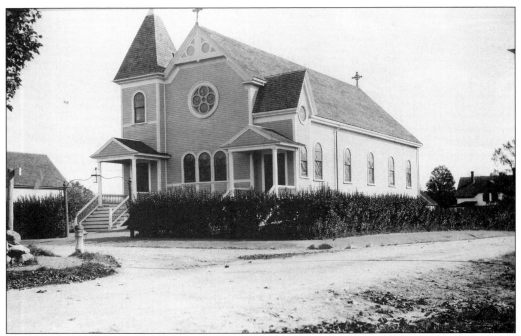

St. Mary's Church on Church Street was completed during the town's centennial year of 1878. An earlier church had been built in 1859 but on March 1, 1862, it burned to the ground. For the next several years, members met in the Cocasset House. Mass was said by priests who rode horseback from town to town serving many churches. In 1877, another church was started but was struck by lightening and burned to the ground.

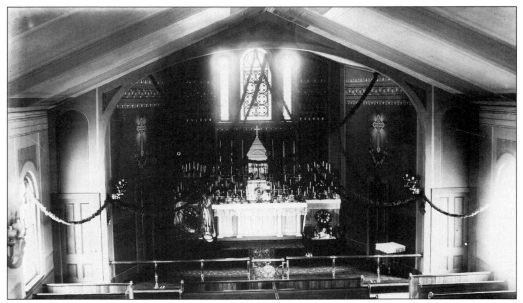

The interior of St. Mary's Church on Church Street, which is now the K. of C. Hall. Saint Mary's Parish was officially formed in 1859, making it one of the oldest in Norfolk County. The new church is located just across the street on Carpenter Street.

Seven

How They Learned

The original District 2 school at the corner of South and West Streets was erected in 1851 by School District 2. It became the property of the town when the districts were abolished and the name was changed to Quaker Hill. Destroyed by fire on September 25, 1925, it was replaced by the present school building, which is no longer used for educational purposes. The Quaker Hill School, like others in the outlying districts, was used well into this century. Quaker Hill had six grades in one room with one teacher. Other similar schools were the Paine School on Spring Street, the Everett School on Main Street, the Pratt School on Pratt Street, and the Plimpton School on North Street. The first school was located on Chestnut Street near Kersey Road. Another early school on Prospect Street was replaced by the Cary School, which was in the building to the left of the Taylor School on South Street.

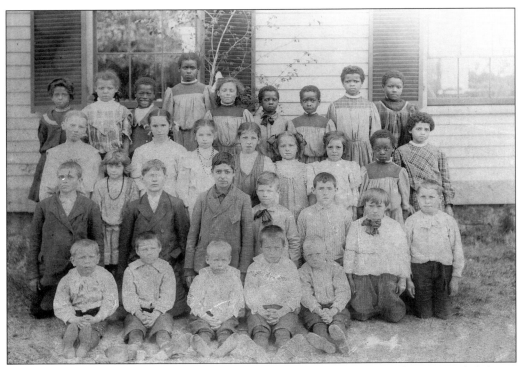

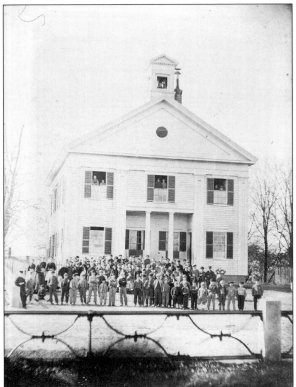

These young students attended the Cary School in District 7. Some were from the Rock Lawn Farm on Mill Street (p. 83), which provided for students from the Boston Children's Aid Society. Jumbled names prevent positive identification, but among the students are Richard Hiller, Arthur Anderson, Carl Anderson, Earl Hicks, Joe Welsh, Elliot Sampson, Harold Proctor, Charlie Sims, John McNamara, Walter Hiller, ? Potter, Bessie Eagles, Mildred Eagles, and Lillian Sampson.

The District 5 school, situated next to the present-day location of BayBank, was built in 1847. By 1849 there were 171 pupils in the center schools. The school was used until the education wing on the Town House was completed in 1873. It was then sold and remodeled as the Samaritan Hall. Today it houses apartments and businesses.

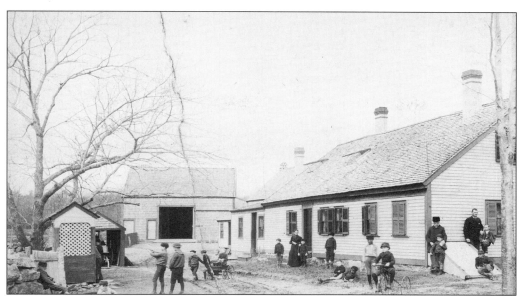

The Rock Lawn Farm on Mill Street was started in the late 1800s by Deacon Charles and Nester Morse (who doubled as a teacher) for the Boston Children's Aid Society. Each Sunday morning, two horse-drawn barges loaded with children headed for Sunday school at Bethany Church.

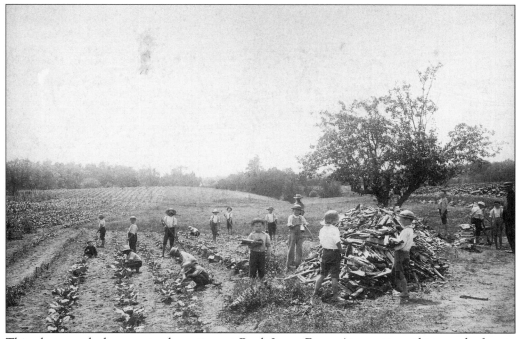

This photograph documents chore time at Rock Lawn Farm. At one time, thirteen deaf-mute children were among the residents. Of the estimated two hundred children housed there over the years, the Morses reported more than 190 of them had kept in touch. The land is now used for the St. Augustine Camp, where the Cowley Fathers provide a summer camp experience for children from Boston.

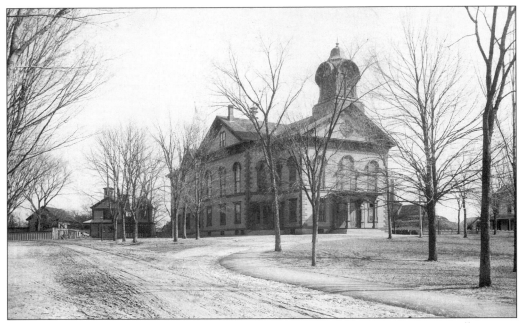

The Town House, the pride of the community, was built in 1857 as town offices. An educational wing was added in 1873. In 1858, Reverend James L. Stone opened the English and Classical High School in the building. Space was reserved for a small number of Foxborough public school students. The school continued until 1865, when the Town of Foxborough established a high school in the same building. The Town House was destroyed by fire in 1900. Three firefighters were killed in the blaze.

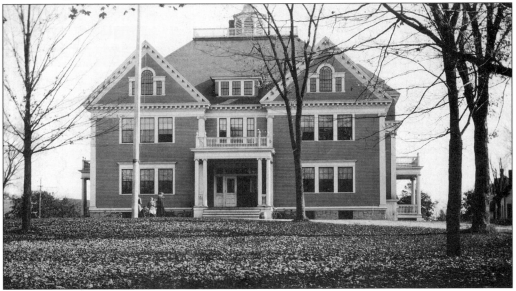

The Center School, the last wood-frame school, was built to replace the Town House. It accommodated high school students until the "new" high school, now the Igo Elementary School at South and Carpenter Streets, was built in 1928. The Center School was then devoted to grades three through six as well as a public kindergarten.

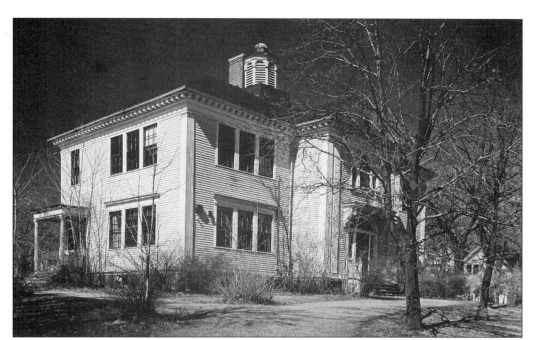

The Carpenter School, built in the late 1890s, stood on the now empty lot across from Friendlys on Central Street. It accommodated two classes each of first and second graders from the center of town. The division of classes was simple: A through M met in one room, N through Z in the other.

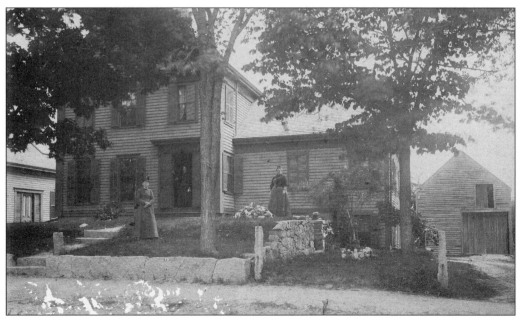

Miss Gray's School for Ladies was founded in 1876 as the Union School. It was located on Central Street at Gray Road.

Walker's Home School was established in 1869 by Leonard Walker. He was the first principal of Foxborough High School when it was established in 1865 and resigned four years later to start a private residential school at 33 Main Street. He served until his death in 1874.

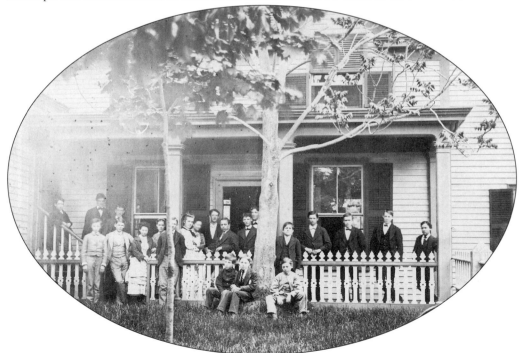

Pupils at Walker's Home School included Laura Clapp, Annie Pond, Fannie Walker, Louise Clapp, Walter Sawyer, Nathaniel Saltonstall, Arthur Pray, Charles Pray, Alex Williams, two Carter boys from Louisiana, and Leverett Saltonstall.

Eight
How They Grew

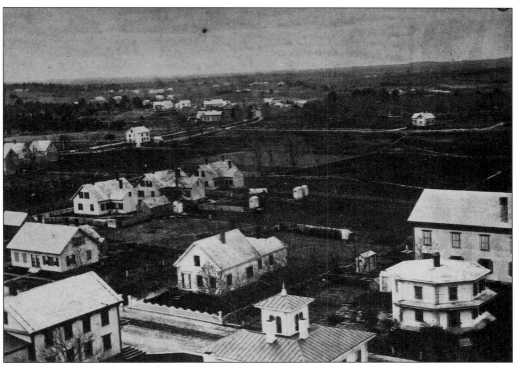

For early photographers to shoot a "bird's-eye view" of the community, they had to lug their heavy equipment up to somewhere that a bird might roost. Any steeple or belfry became fair game, and the spire of Bethany Church was most often the location of choice. Many of their large glass negatives, in prime condition, safely repose in Memorial Hall, although the identity of their creators often remains a mystery. Lewis Thomas had a photograph shop on Centennial Street, as did C.A. Stevens, who created many stereoscopic views of the community. Someone in the Hedges family did a lot of photography, and Frank Pond had a stereo studio behind the family home on Baker Street (p. 23). This photograph from the Bethany Spire looks down on what is now the Keating Funeral Home. Next door is Garside's Tin Shop (p. 98). The octagonal house was built about 1855 for Miss Abbie Dean, who worked in the straw hat industry. Considerable restoration work was done by Mr. and Mrs. Paul Shields. Behind that home is the Masonic Temple. And what are all those small buildings everyone seemed to have in their back yards?

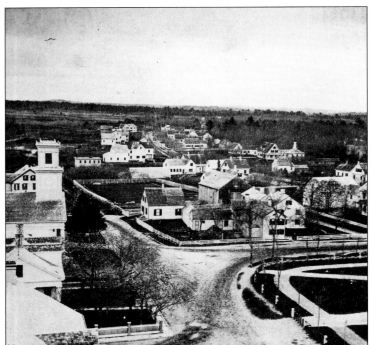

Looking down from the Bethany Spire toward Bird Street, the Universalist church can be seen on the left. The large farm complex in the center of the photograph was Deacon Baker's (p. 16). This photograph appears to have been taken shortly after the Common was laid out in 1857.

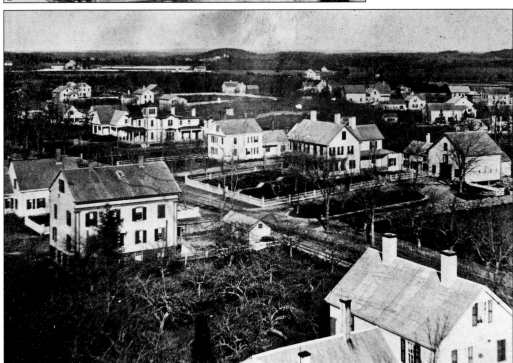

In this view looking down Main Street, the large house and barn with the fence on the right was used as Walker's Home School (p. 86) for many years. The next building was the parsonage of Bethany Church, and the one after that was the mansion built by Virgil Pond (p. 37).

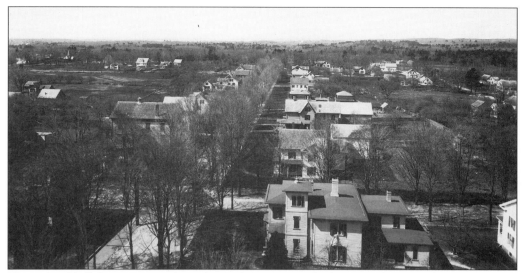

This is Rockhill Street as seen from the Bethany Spire. The home in the immediate foreground was removed to allow the building of the Barton Chapel and educational wing at Bethany. Rockhill Street was laid out in 1850, the same year it was decided the cemetery in the center of town was full. A new burial place was planned, and Rockhill Street became the link from the center of town to what would be for many years the main entrance to Rock Hill Cemetery.

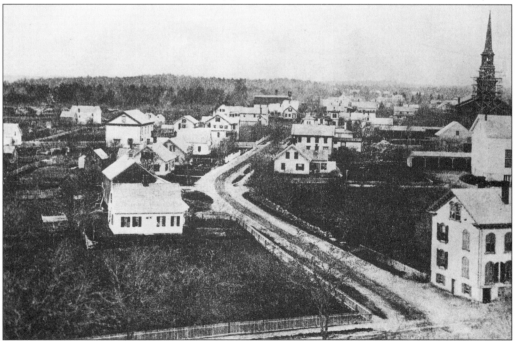

This photograph was taken from the belfry of the Town House (p. 84), which burned in 1900. The vacant lot in the foreground is now occupied by the Lutheran church. The American House is at the right, and to the extreme right the rear of the Baptist church with its carriage sheds can be seen. In the background is the spire of Bethany Church, surrounded by scaffolding. Looking up Market Street, one can see Pond's Steam Mill.

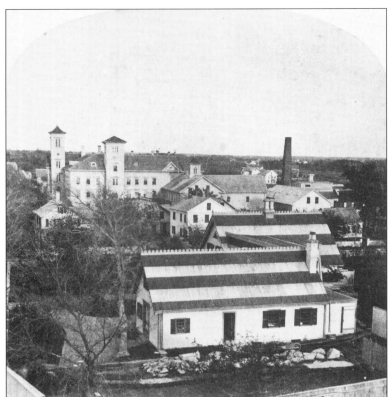

This photograph was taken from the Town House looking across the home of E.P. Carpenter (p. 41) to the sprawling complex of the Union Straw Works (p. 40) on Wall Street. Both the Town House and the Union Straw Works burned in 1900.

This view, from about 41 Main Street, looks down the rest of the street. Main Street was in use as early as 1750 as the Cape Road from Wrentham. It was formally laid out in 1822.

Note the hitching posts (where visitors might tie their mounts), the raised sidewalks, and the gas lights in this view looking down Central Street in the late 1800s. The first lights were installed in 1873 by private homeowners. Various groups then got involved in installing lights. When responsibility was shifted to the Village Improvement Association in 1890, the town made an appropriation to install and be responsible for lights.

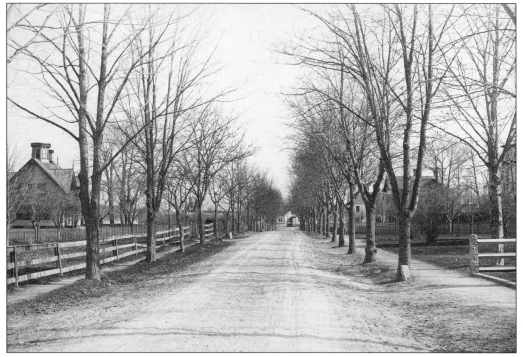

Looking up Baker Street toward the center of town, the "gingerbread house" is on the left. Baker Street once started at the Common, but was changed with the building of Bird Street.

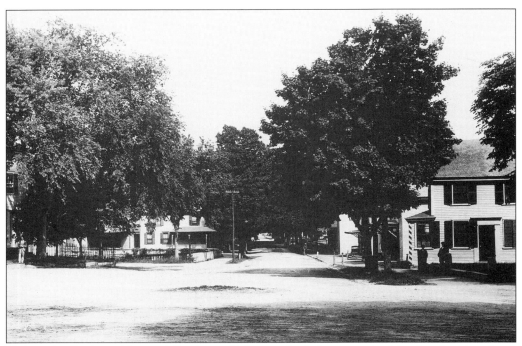

Today, the Foxboro National Bank would be on the left corner in this view looking down Cocasset Street toward East Foxborough. The first house on the left is now the home of Mr. and Mrs. Vincent Igo and was once the Sumner livery stables. On the right is a barber shop and other stores.

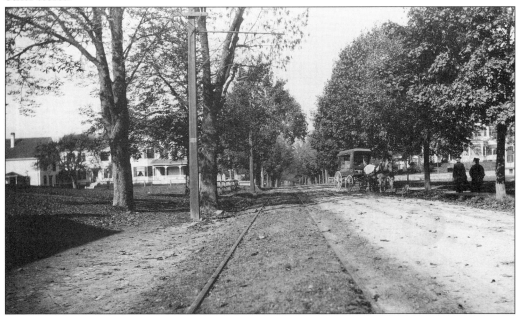

This photograph of Main Street was taken during the trolley era. The line ran down Main Street to North Street as it headed for Walpole and Norwood. Roads were still gravel and deliveries, as noted by the activity, were by horse and wagon.

Nine

How They Came
of Age

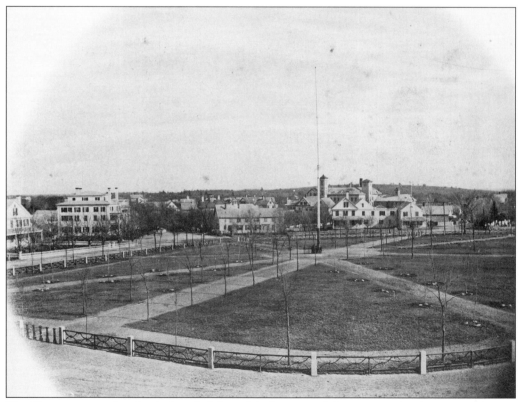

The Common was the physical and philosophical center of the community. It was to this spot the people were drawn when first building a Meeting House in anticipation of being "set aside" as a town. To beautify the area in 1857, the Sylvanian Association was formed. Walkways were laid out, trees planted, and a flagpole erected. The fence was cast at Cary's Foundry on Mill Street (p. 34). When the Common was in need of restoration in 1972, we let history be our guide, and launched a private effort to restore a community treasure. The people responded.

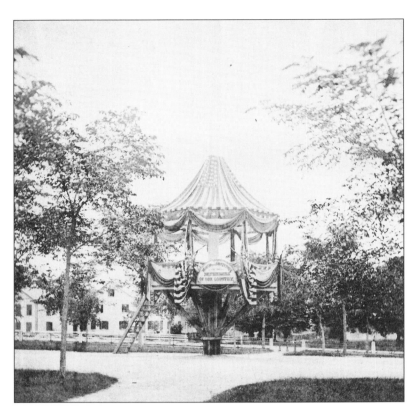

The first bandstand was built around the flag pole in the center of the Common. Decorated for the centennial in 1878, the sign reads "Honor and Gratitude to the Defenders of our Country."

The second bandstand was built near the walkway leading to the fire station. Once it was removed, there was no bandstand until the present structure was built by the Foxboro Jaycees.

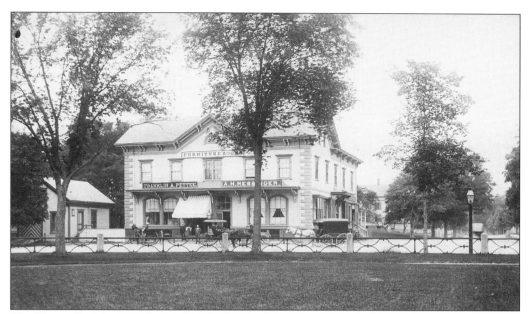

The Union Building was located at the head of the Common, on the site of the present Getty station. The merchants doing a brisk business in 1890 included Franklin A. Pettee's Dry Goods Store and A.H. Messenger, grocer. C.G. Hodges had a furniture showroom in the upstairs rooms.

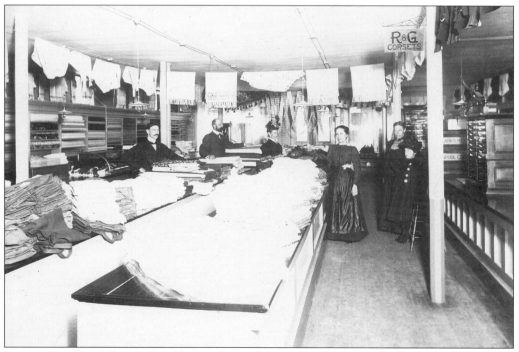

Pettee's Dry Good Store offered boots, shoes, dresses, shawls, and umbrellas, as well as trunks, traveling bags, and R&G Corsets. Mr. Pettee was also an agent for "the old and reliable" Malden Dye House and sold Demorest $19.50 Sewing Machines.

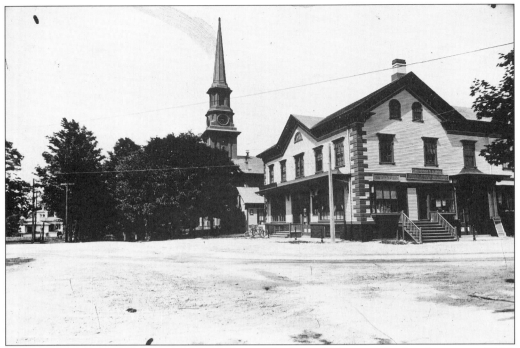

This is a later view of the Union Block. Union Block would become the headquarters of F.M. Perry & Son, which took over management of the electric railway company and also ran a large bus company. The first motion picture in Foxborough was shown in this building on January 1, 1910. Films were shown here until the Orpheum Theatre was built in 1927.

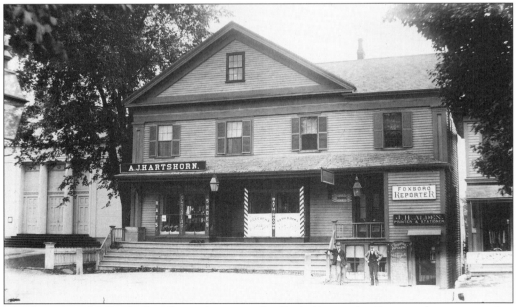

The Samaritan Hall, which still stands next to BayBank (facing the Common), was erected in 1847 as a schoolhouse. A.H. Hartshorn, selling hats, clothing, and shoes, replaced Butterworths (1861). The *Foxboro Reporter*, started in 1884, was bought out by Joseph. H. Alden in 1887.

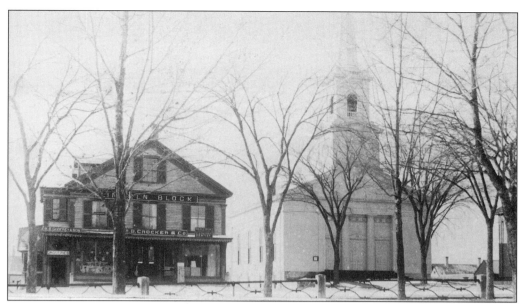

The Lincoln Block, completed the year President Lincoln was inaugurated, was named in his honor. It housed a variety of stores over the years, as well as professional offices and rooms for boarders. It stood beside the second Baptist church, which was built in 1850. The steeple of the church was weakened in the 1938 hurricane and had to be removed. Both buildings were demolished to allow the building of BayBank.

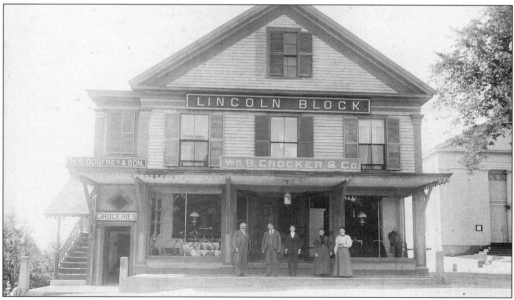

At the time of this turn-of-the-century photograph, the tenants of the Lincoln Block included Godfrey's grocery store and W.B. Crocker & Co., which sold black silks, Henriettas, cashmeres, dress fabrics, and underwear for ladies, gents, and children. Gathered for the photograph are W.B. Crocker, J.W. Richardson, Thorve Carpenter, Lizzie Hitchcock, and Nellie Capen. The building was also used as a post office until the present facility was erected across the Common in 1939.

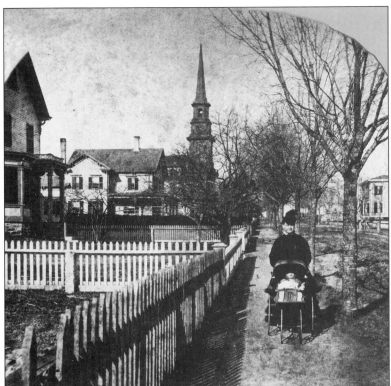

As this woman took her baby for a walk down Rockhill Street, virtually everything she needed could be found within walking distance of the center of the village, as it had emerged as a self-contained society. At this time, the majority of jobs, as well as the shops and services, were located in the center.

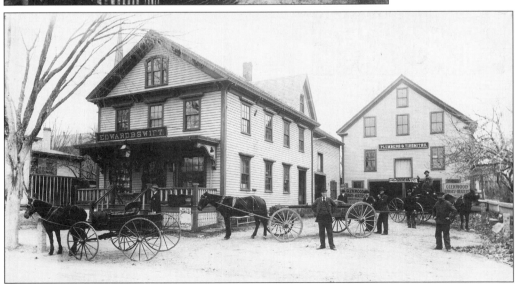

Employees of the Edward B. Swift Company on Market Street proudly show off the firm's Glenwood ranges and heaters. The building originated as the Garside Tin Shop, a business that began in the basement of the Friendship Block. Garside moved out in 1858 and by 1888 Swift was in operation. The building was used around 1896 as the Dodkin Hat Co., but was eventually demolished. The area is now the parking lot to the rear of CVS, adjacent to the Keating Funeral Home.

This is a rare interior shot of the Hedges homestead on Central Street. The room shown here would have been the parlor or living room of a family that lived very comfortably around the turn of the century.

Somebody in the Hedges family was involved with photography, as many of the glass negatives now owned by the Foxborough Historical Commission attest. This view is of the dining room in the Hedges home. The family was involved in the town's first automobile dealership and service station (p. 68).

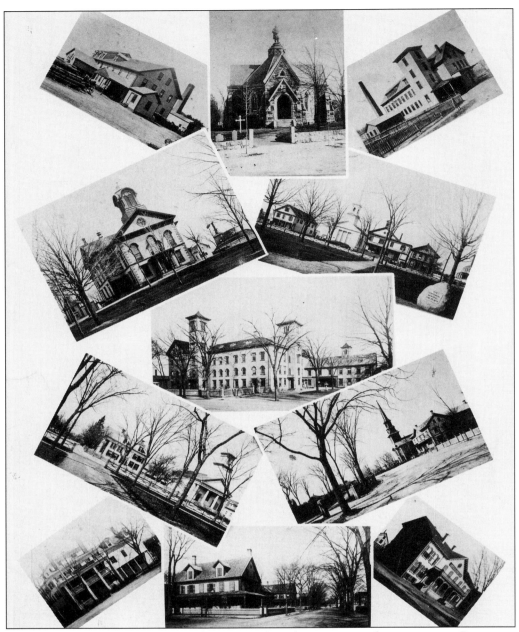

The mid to late 1800s were a time of great growth and prosperity in the community. Beginning at the top, moving from left to right, are: (top row) Pond's Steam Mill, Memorial Hall, and the present Sentry Company; (second row) the Town House (note the fire station to the left and the stone reservoir and windmill to the right) and a panoramic view of the Lincoln Block, Baptist church, Samaritan Hall, and a store on the site of David Bragg's home; (middle) the Union Straw Works on Wall Street; (fourth row) Colonial Court and the Universalist church and, in the right photograph, the Union Building and Bethany Church; (bottom row) the Cocasset House, the Great Bonnet Shop (now apartments) on Wall Street before the Union Straw Works was built, and American Hall on South Street.

100

Ten

A Self-Contained Society

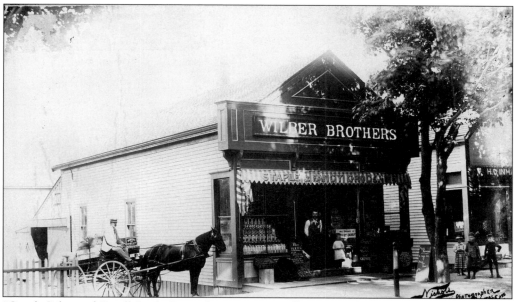

"Quick Sales and Small Profits" was the motto at Wilber Bros., the only cash grocery store in town, according to their ad in the 1890 directory. Located on the main business block in the center, the business would later become the Cash Store under the management of Annie MacIntosh. Today, it is the Country Emporium. Wilber Bros. was part of a vibrant mix of business activity spreading out from the center of town in a self-contained society that would remain strong through the turn of the century.

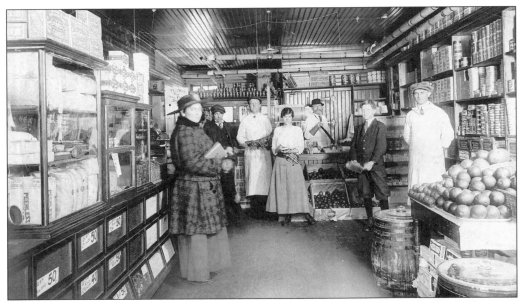

The ladies patronizing Wilber Bros. enjoyed a luxury denied to their mothers, who had to raise their own vegetables and put them away for the winter. Stores like Wilber Bros. offered canned meats and vegetables, fresh coffee and tea from exotic places, and an assortment of fresh fruits and vegetables.

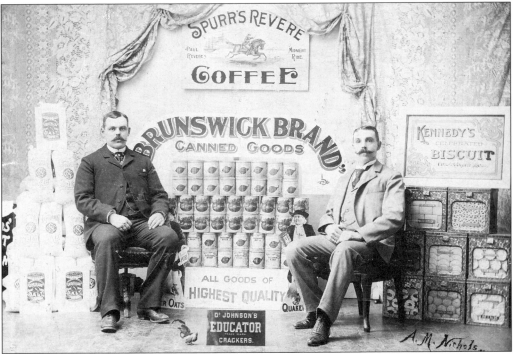

The Wilber brothers themselves, Sumner and Frank, posed for this photograph by A.M. Nichols, which was used on the store's calendar that year. Bags of salt and flour, tins of biscuits and crackers, and canned goods that knew no season were all that any homemaker could desire.

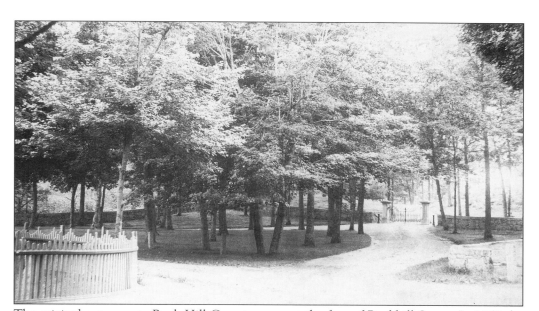

The original entrance to Rock Hill Cemetery was at the foot of Rockhill Street. In 1852 the original 13 acres for the cemetery were purchased, primarily from E.P. Carpenter and Otis Cary, for $489.58. Other land was bought and some sold, reducing the net cost of the original parcel to $103.58.

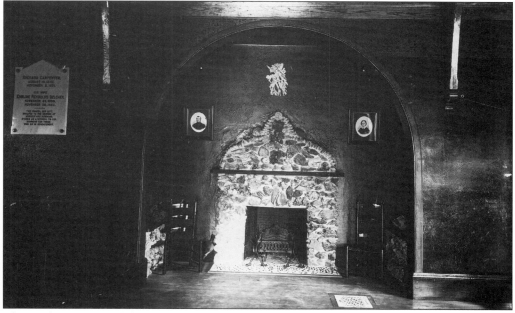

This is the interior of the Carpenter Memorial Chapel, which was erected in 1894 under the terms of the will of Emeline Reynolds Carpenter as a memorial to her and her husband Richard. In 1889 additional land was purchased to create an entrance off South Street to the cemetery.

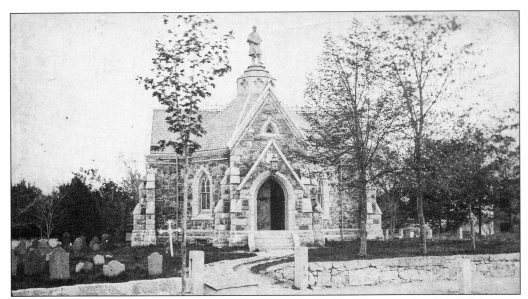

Memorial Hall, erected by a grateful community in 1868 following the Civil War, was dedicated "to all of those whose lives were touched by the war." It was built at a cost of $13,000. Members of the building committee added an interior stained-glass window at their own expense, and were later reimbursed by the town. Now the town museum, the building is open every Wednesday night from 7 to 9 pm.

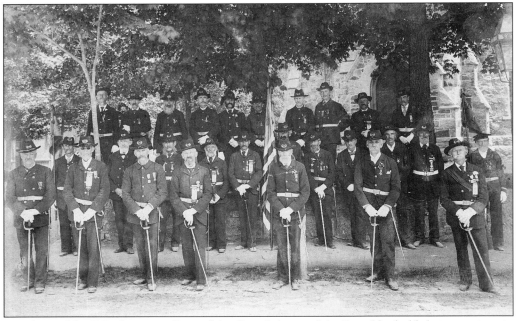

Members of the E.P. Carpenter Post of the Grand Army of the Republic held their meetings in Memorial Hall until 1871, when the town opened a public library in the building. The library was named for Uriah Boyden, who years earlier had donated money to improve the schools. The money was used instead to purchase the first books for the library. The library remained in Memorial Hall until the present library was opened in 1967.

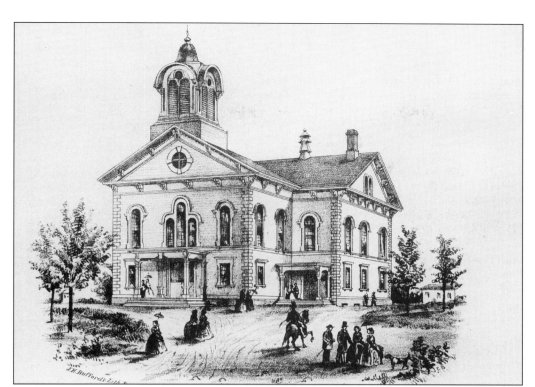

The English and Classical High School (p. 84) was opened in the Town House in 1858 by Reverend James Stone, a Unitarian clergyman from Providence. It was a private school but a specific number of openings were reserved for Foxborough students. The school continued until Foxboro started a public high school in 1865.

These were some of the students at the English and Classical High School. Founder James Stone is the man with the beard. Students studied Greek, Latin, French, German, geometry, advanced algebra, shorthand, and rhetoric. Many of the students enlisted in 1861, when Company F of Foxborough was called to duty during the Civil War.

The horse and wagon tracks of one age may have given way to the horseless carriage ruts of another, but winter is still winter in the village. Fortunately, since the very beginning, the community has benefited from outstanding service by the Highway Department in keeping roads passable.

The Bramble Club remains a mystery, but notes indicate this photograph was taken on Thursday evening, May 4, 1905, by Mr. C. Slocumb—using a flashlight for illumination. Some of the ladies are Lu Young, Mrs. Slocum, Bessie Hedges, and Marian Wheeler.

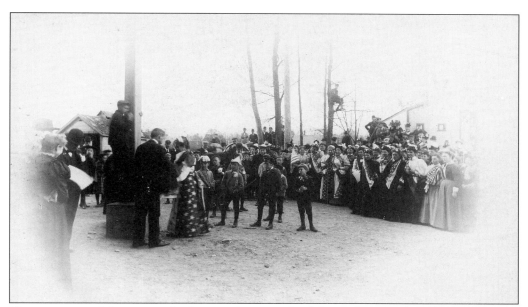

This patriotic celebration took place on the grounds of Caton Bros. Bixby. The hat factories attracted large numbers of female workers who became a commanding presence in the community. They took the lead in many civic projects, undertook fund-raising activities for the community, and made a great contribution to the quality of life in the village.

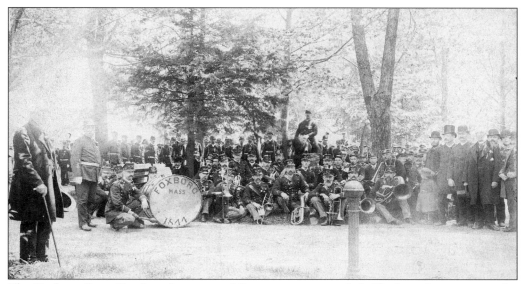

The Foxboro Brass Band made many public appearances on behalf of worthy causes in the community. Many events were elevated to community celebrations by the presence of the band, such as a new piece of fire apparatus being delivered by train.

The Foxboro Laundry Co. building, located on Mechanic Street, was removed to allow the construction of the Man-Mar complex. Henry C. Folsom started the laundry business in the stone house on Granite Street in 1869. In 1871 the business was purchased by Captain Ezra Pickens.

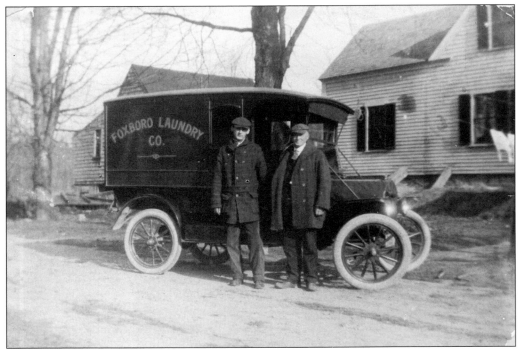

Not only could women enjoy the convenience of sending the laundry "out," but it was picked up and delivered. And they had a choice: wet (you would still have to hang it out on the line to dry) or dry (ready to iron and wear).

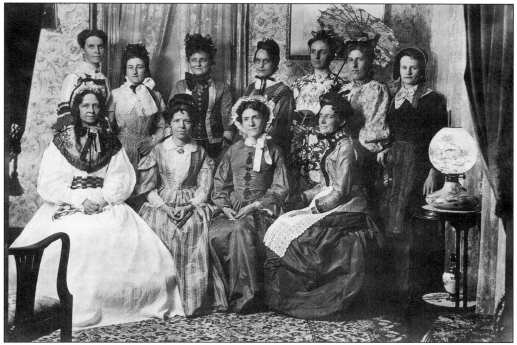

The women were the moral driving force of the community, and "The Trusting Ten" organized the King's Daughters. Their motto was "Trust in Him at all times." The record leaves us with six names for seven people in the back row: Jenny Carpenter (Snell), Mrs. Shackley, Miss Lou Lindley, Jennie Lindley (Gray), Emma Hodges (Cook), and Bertha York (Alden). In the front are Mrs. Jared Swift, Nellie Capen, and Edith Bourne.

The boys were boys, and some of them kept hounds for fox hunting. Howard Braun of Howard Avenue was part of this group, which must have considered their day very successful.

The Great Bonnet Shop and the Verandah House on Wall Street were used for straw hat manufacturing, but when the business prospered, the Union Straw Works was built across the street. These buildings were then converted to boarding houses, a necessary consideration for any manufacturer needing to attract large numbers of women to a work force. They are now used as apartments.

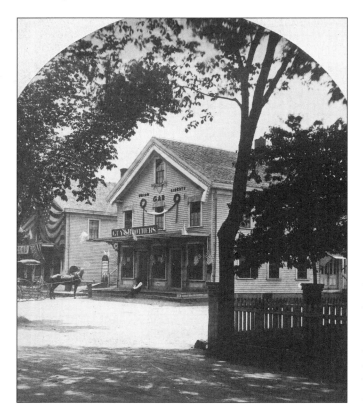

Guy and Brothers on Wall Street sold groceries and home furnishings. The company succeeded Fales & Pierce in 1874 and had branches in Boston, Lowell, Lynn, and Fitchburg. The building is decorated for the centennial in 1878.

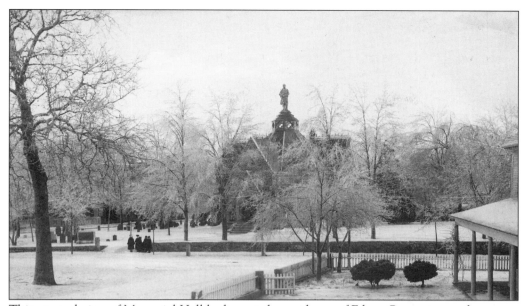

This unusual view of Memorial Hall looks past the residence of Edson Carpenter on the corner of School and South Streets. The home of Jeremiah Hartshorn, who donated part of the land for the Common, once occupied this site. The building in this photograph was moved around the corner and is now apartments. The present Moore Building was then erected on the corner.

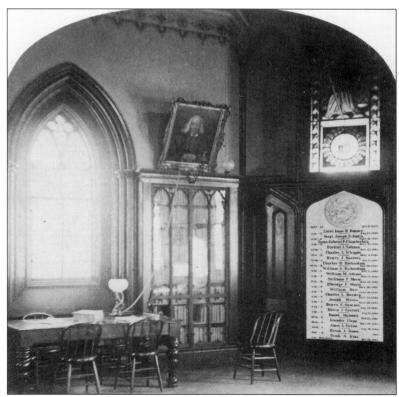

This photograph is of the interior of Memorial Hall, when it was used as a library. A social library was started in 1860; ten years later the town voted to start a public library, which opened on January 30, 1871. The first books were purchased with $652.77 in interest from a $1,000 donation given by Uriah Boyden. The library was named in his honor.

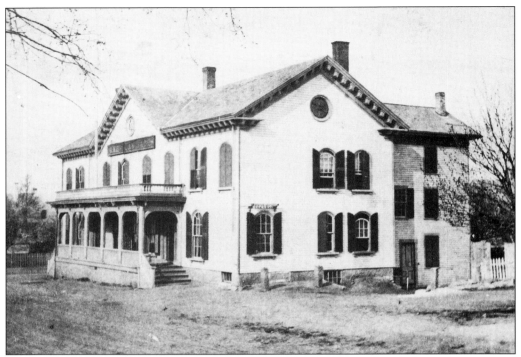

The American Hall, located on South Street next to the Lutheran church, housed a variety of business and office activities over the years. Town meetings were held there from 1856 to 1858. The Foxborough Savings Bank was incorporated there in 1855 and the first meeting of the Episcopal Mission was held there in 1890.

The Center School was built following the fire which destroyed the Town House in 1900. On the upper level it included a stage for various school performances. The building served as a high school until the "new" high school (now the Igo Elementary School) was built in 1928.

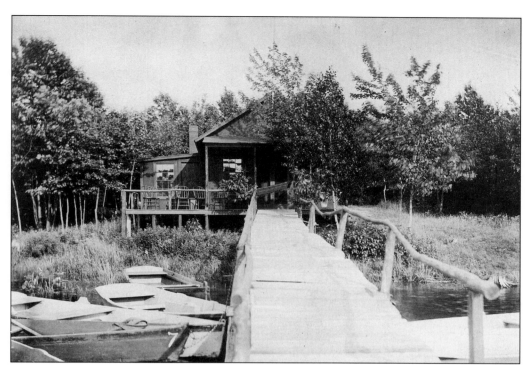

The Foxboro Boat Club was located on Kersey Point in the Neponset Reservoir. It was started in 1906 on "The Bogs," as Neponset Reservoir was called. Thirty-five shares of stock were authorized at $20 each. In 1933, the land and buildings were leased to Foxboro Fish & Game, and eventually the land was donated to the town for conservation purposes.

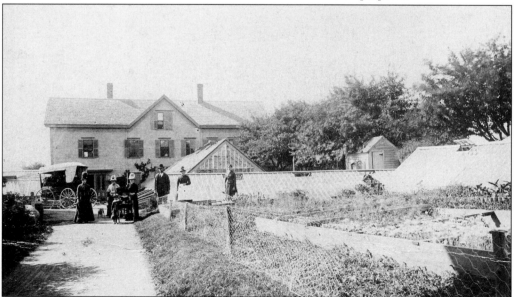

Small's Greenhouse, located on Garfield Street, was started in 1877 and greatly expanded in 1880. It was run for many years by Clifton Guild, the organist at the Baptist church. The last proprietor was the late Ginny Wheeler.

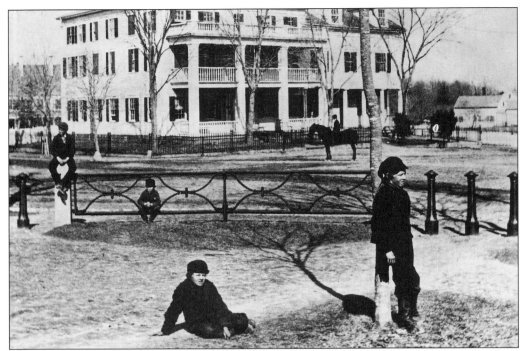

The Cocasset House was built in 1846 on the present site of the Foxboro National Bank. Town meetings were held here from 1847 to 1856. The proprietors also had a livery stable, and advertised that "Mr. A. furnishes bells for the horse and leaves the matter of furnishing belles for the sleigh with those gents who may favor him with a call."

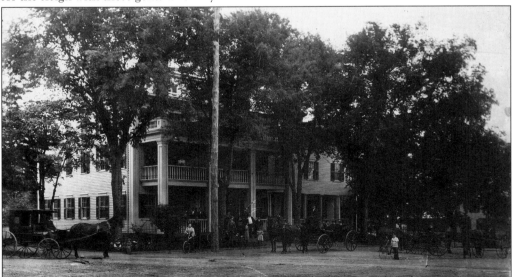

A later view of the Cocasset House, which did a brisk trade with businessmen brought to Foxborough by the straw hat industry. Foxborough was also highly publicized as a vacation spot. Soldiers mustered into military service during the Civil War were sworn in on the steps of the Cocasset House before marching to East Foxborough to board the train for the trip into Boston for assignment.

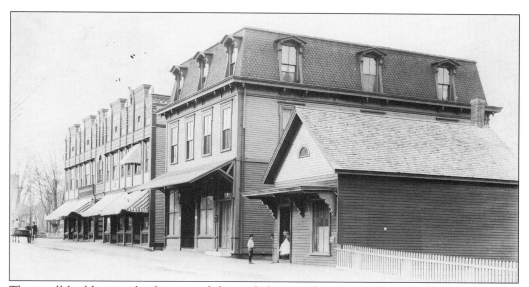

The small building in the foreground, located about midway in the business block on Central Street, was the first post office in the center of town. In 1893, the postal service ordered the "u-g-h" dropped from Foxborough's official address. The building was later moved back from the street and it was last used in the 1970s by Chester Cutler as a bicycle shop. The adjacent building is the Phelps Pharmacy, erected by Eli Phelps about 1850. It later became Ouimet's Drug Store. The top two floors have been removed and it is now the Commons Eatery.

The interior of the Phelps Pharmacy had an elaborate soda fountain. The ingredients of most prescriptions were mixed by hand. When operated as Ouimet's Drug Store, members of the high school football team were treated to free frappes every time the team won a game.

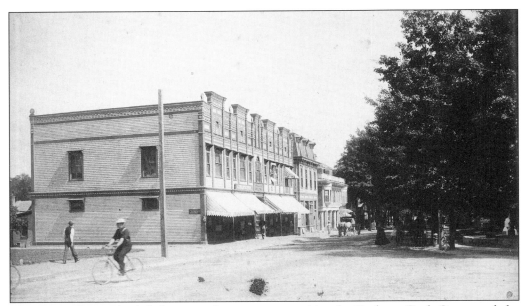

The vacant lot in the left foreground is now occupied by the Foxboro Craft Co-op and the Trading Post. The large building with the awnings is the Crocker Building, erected by William Crocker in 1893. It has been occupied, at various times, by Gray's News Store, Hartshorn's Mens Clothing Store, Fairbanks Bakery, and the Dow and Paterson Meat Market. The second floor was occupied by the Odd Fellows Hall.

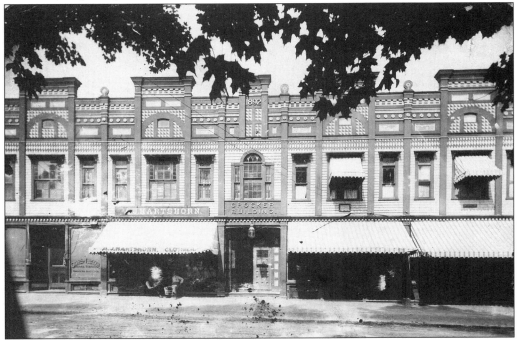

The front of the Crocker Building is shown in this view. More recent occupants of the building were Hanna's Restaurant, the Juke Box, Vinnie the Barber, and Hutchins 5¢ to $1 store. The building, once the showpiece of the business district, is now in a state of disrepair.

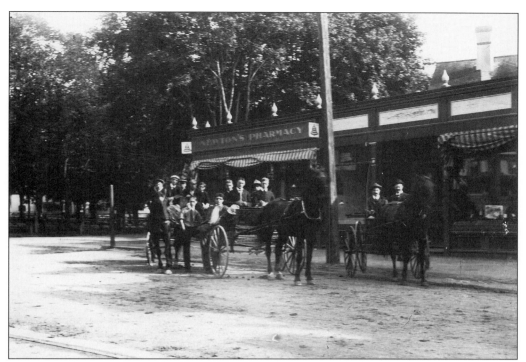

Newton's Pharmacy, erected on the corner in 1898, is now the Foxboro Craft Co-op. The pharmacy was later the Bay State Drug Store, operated by John Moran and Bill Dacey. It was then bought by the O'Reilly's. Mrs. O'Reilly later operated a gift shop in the building.

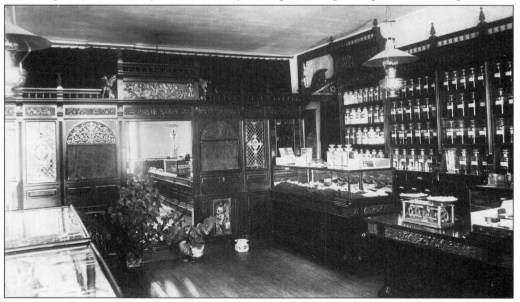

This view of the interior of the Newton Pharmacy shows the busy soda fountain, for which Bill Dacey made all the syrups. The soda fountain was the only place to buy ice cream in bulk, and each half-pint or pint had to be scooped and packed by hand. The going price—when a budding author did his tour of duty in the late 1940s—was 25¢ for the half, 45¢ for the pint.

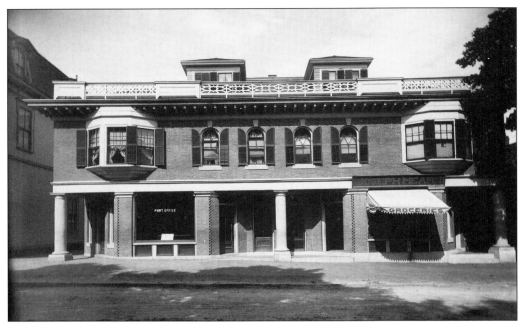

The Brick Block was built by members of the Phelps family in 1898. It has housed a variety of businesses through the years: the post office was located here for ten years; Moore's Dry Goods Store was housed here for many years, selling yard goods, sewing materials, and clothing for the ladies; First National operated from the building; and Aubuchon's Hardware Store was located here for some time as well. The building was severely damaged by fire and demolished. Aubuchon's moved to its present location and was burned out again, but returned.

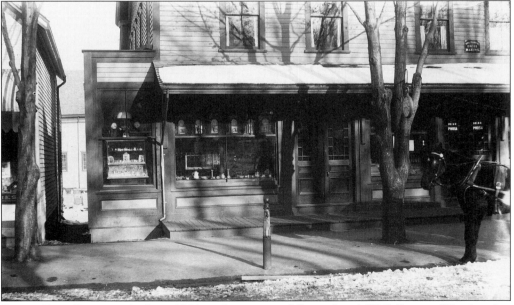

Bassets Fruit Store was built in 1889 at the corner of Central and Wall Streets. Watchmaker Leon Hapgood was located there, as was the first office of the Foxborough Cooperative Bank. The building was owned by Harry Natsis for many years and is now Central Wine and Spirits.

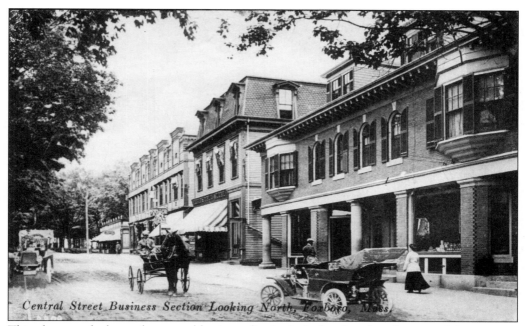

Central Street Business Section Looking North, Foxboro, Mass.

This photograph shows the central business district in its heyday after the turn of the century. In addition to the ground-level stores, there were professional offices and residential apartments on the upper levels. The Odd Fellows Hall had an oyster saloon, and there were at least three food stores in the center at any given time.

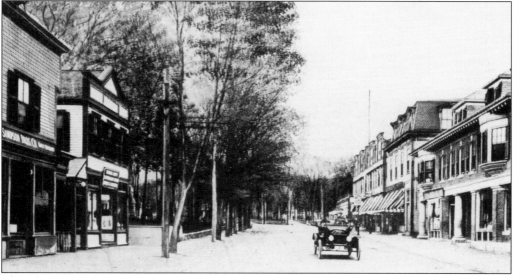

This glimpse of the left side of Central Street, looking toward the Common, reveals another row of stores located where Foxborough Federal Savings & Loan now stands. Howard Newton built his first pharmacy next to Memorial Hall. Other familiar tenants along the strip included: Fuller Bros., where most of us saw our first television program; Dr. Livermore's office; J. Venner Makant Insurance; Fitzie's Pioneer Food Store; a Chinese Laundry; and Koski's Jewelry Store. In addition, Martha Bell had a hairdressing shop and Harold "Duck" Clark, later to be fire chief, tried his hand in the restaurant business here.

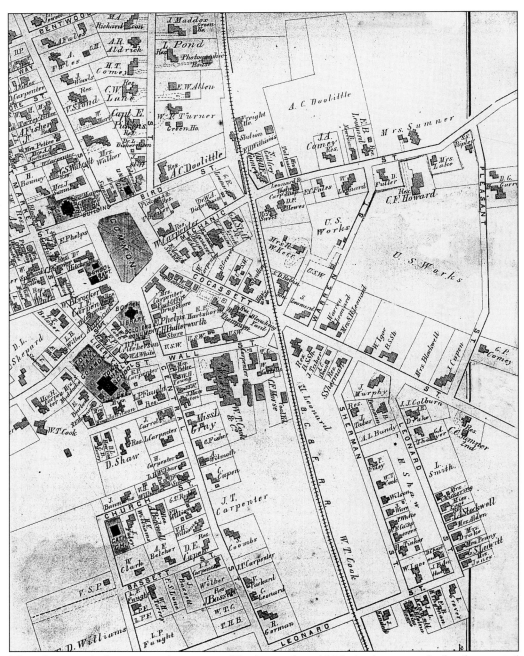

This photograph documents the center of Foxborough in 1876. At this time, the land occupied by Wilber's Store and Basset's Fruit Market was still being used by the Union Straw Works to bleach straw. This was done by placing it on wooden racks in the sun; when it was bleached and dried, it would be taken back to the factory on Wall Street to be used in the manufacture of straw hats.

Eleven

Transition Years

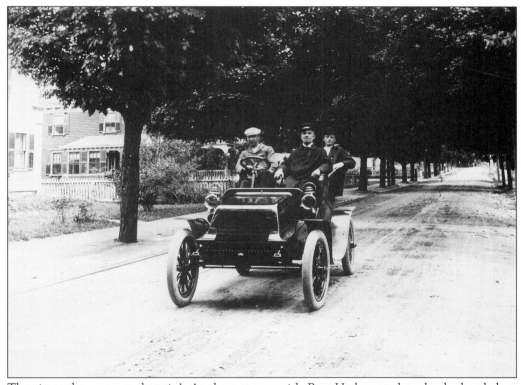

The times they were a changin'. As these men—with Bert Hedges at the wheel—headed up Central Street, they were rushing headlong into the future, and an ever-changing community. Fire and obsolescence would claim the huge factories in the center. The community would recover from the devastation ushered in by the new century and, with the steady employment offered by the Foxboro Company, the quality of life in the village would be sustained.

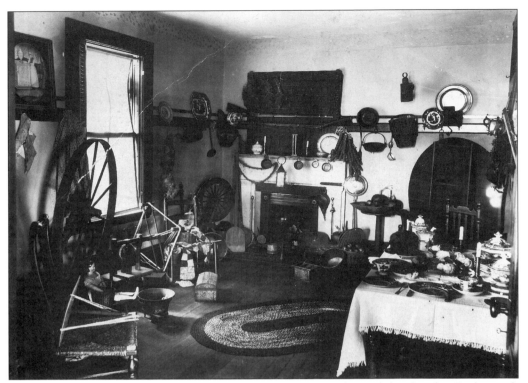

The community would continue to revere its past, as in this exhibit by the Foxborough Woman's Club in 1919. But in celebrating their past, they reaffirmed their commitment to the future in the realization the two are inexorably linked.

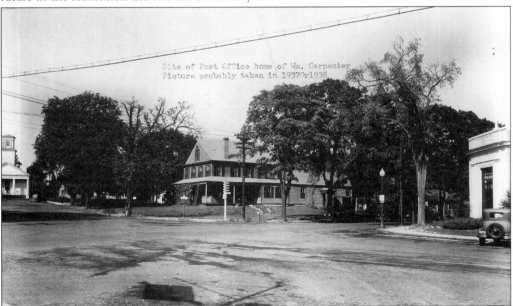

The stately home of William Carpenter, which graced the most prominent corner in the center of town, would be removed and a post office would rise in its place.

The stage curtain at the South Foxboro Community Club would feature a new lineup of local businesses, with some of the more familiar names already fading from the local scene.

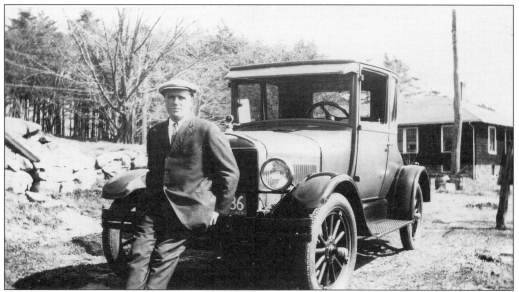

Robert "Bob" Green, whom many will remember living at the corner of South and Water Streets many years ago, was symbolic of the new age, the mobility, the freedom, the independence which we eagerly sought to embrace.

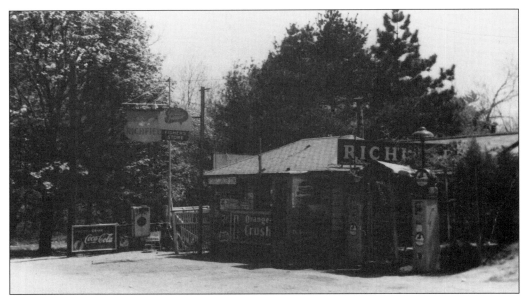

There were still neighborhood identities. Fishers Store on Chestnut Street was located next to the railroad tracks on the way to "The Bogs," which offered some of the finest fishing and swimming in the area. An Orange Crush and a Devil Dog for 10¢ really made the day. Today, the store is gone, and a battle wages to rid the lake of chemical contaminants, a challenge that could linger into the next century.

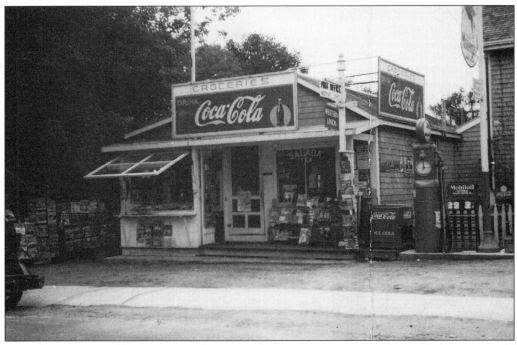

Mrs. Champagne held the neighborhood together on Main Street and served the locals cold drinks, ice cream, groceries, and candy. And for $1 (and usually less) you could buy enough gas to keep the jalopy running all week long. Could life get any better?

Twelve
How They Celebrated

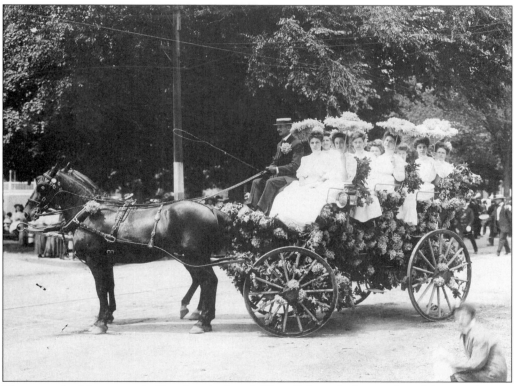

The years had been good. One hundred and fifty of them had passed, and it was time to celebrate. The sesqui-centennial was celebrated on Friday, June 29, 1928, as well as Saturday and Sunday, and it was a grand celebration indeed, or so it would appear to those of us who read news accounts of the day. History failed to record the names of these celebrants, believed to represent the Fortnightly Club of East Foxborough, with Mrs. Langdon and Mrs. Seltsam in charge. The decorations were in black and orange, with hats and parasols to represent black-eyed Susans. Perhaps in their anonymity, they represent all women who were such a vital part of the community.

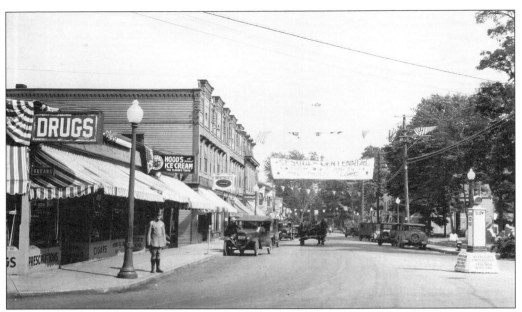

It was a grand day for a parade. Buildings were hung with buntings, a banner stretched across the parade route, and a sense of celebration and anticipation filled the air.

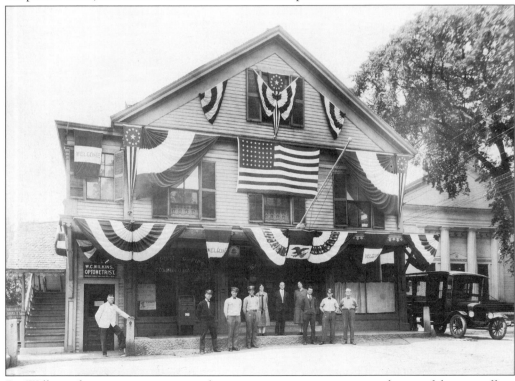

Dr. Wilkins, the optometrist, was out front to greet visitors, as were employees of the post office, located in the Lincoln Block. The postal staff had grown, with home delivery (twice daily in the center) inaugurated just two years earlier in 1926.

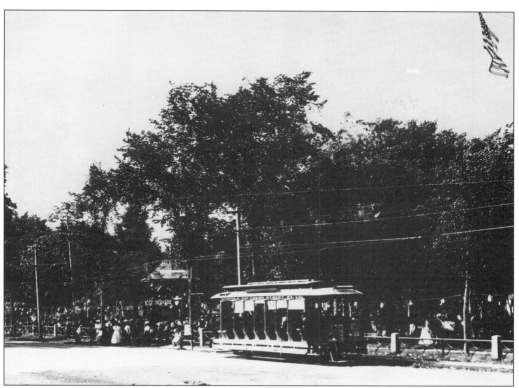

The Common was hung with Chinese lanterns. There was a sesqui-centennial birthday cake and speeches long into the day. The Norfolk and Bristol Street Railway Co. ran special cars to bring the thousands of celebrants to the center of town.

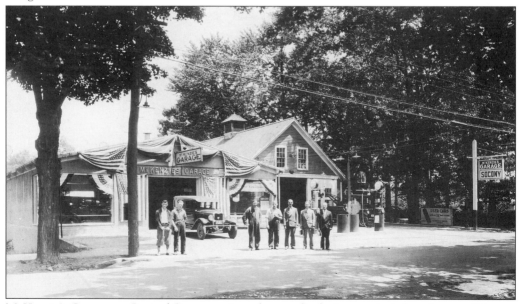

McKenzie's Garage on Central Street got into the act, displaying patriotic buntings, as did most businesses and many private homes along the parade route.

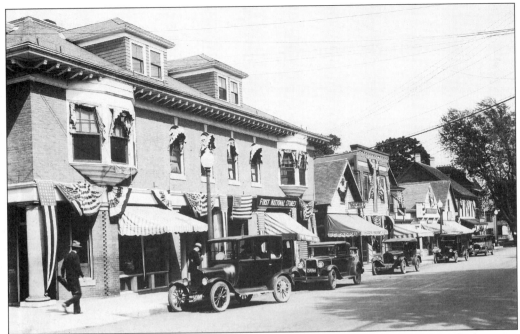

And so it was that a community celebrated its first one hundred and fifty years, proud of its past, challenged by its future. The downtown area of today is but a shadow of its former self: perhaps this is the price of greater mobility, and the economic forces which shape such a large part of our lives. But there are hopeful signs of revitalization, leading us to a date with destiny. The community will prove up to the challenge.

This is the scene most fondly remembered by those serving in World War II. The "Foxboro" signs were removed in 1995 in favor of combination signs and message boards for community events. One sign will be returned in early 1996, keeping faith with all those who had added their own measure to the sense of community that has set this place apart since the beginning.